STREET ART
COOKBOOK

Benke Carlsson: to Emanuel and Arsema
Hop Louie: to zero tolerance

Benke Carlsson is a photograper and author living in Stockholm, Sweden. He has previously published "Street Art Stockholm" and "Swedish Punk 1977-81", and runs a small gallery (C/O Hornstull) and Bly Publishing. Benke also works as head of strategy at OTW Communication and is a well known educator within communication and culture.

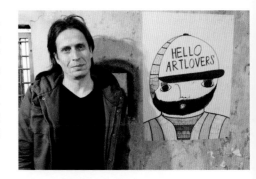

Hop Louie is a Swedish street artist who has worked in public space with foremost stencils and posters since the 1990s. His works often comment on current political and social issues. Hop Louie has been featured in several books.

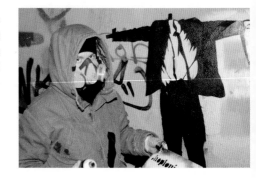

In many countries, it is illegal to make art on the street without proper authorisation. Always make sure you have proper authorisation before getting started.

© Dokument Press, Benke Carlsson & Hop Louie 2012
Third edition, first printing 2024
Printed in Poland
ISBN 978-91-88369-88-8

Dokument Press
Årstavägen 26
12052 Årsta
Sweden
hello@dokumentpress.com
dokumentpress.com
@dokumentpress

Photographers, see page 136
Text: Benke Carlsson, Hop Louie
Foreword: Shai Dahan
Editor: Tobias Barenthin Lindblad
Translation: Martin Thomson
Graphic design: Martin Ander
Layout: Sebastian Spaanheden

Thanks to everybody who supported this book with photos and knowledge.

INDEX:

FOREWORD BY SHAI DAHAN

Creativity in street art is a reflection of the human spirit. It is an affirmation of our capacity to create, communicate, and connect with one another. It reminds us that art is not a privilege for the select few. That's what this book is about; sharing the lesson that we are all creatives.

When I was asked to write a foreword to this book, I had to approach it both as an artist and as someone who loves the street art movement. This is more than just an ordinary street art book. It will guide you in creating your own art, learning the techniques directly from the masters of this movement. It is also a celebration of the artists who transform blank walls into living testimonials of human expression, reflecting the vibrant diversity of our cultures, dreams, and struggles.

But how did they get here? We are always presented with the artist's success, but rarely do we get to know "How?" So, when I was thinking about how to best capture the essence of this art form, I realized that I needed to let you know something personal.

As a professional artist, muralist, sculptor, street art festival founder and curator, who has been working with companies and won awards, I will tell you how I started out. A personal story that will hopefully inspire you to be creative. Even through past mistakes.

My story is about "Young Me". I'm now grown up, and sometimes, with age, you realize that there's a lot of risk involved. If there's anything I hope you will take away from this, it is that chances are that you will get into serious trouble if you break the law.

I grew up in a suburban area of Los Angeles called The Valley – a circle of suburban homes with a shopping mall in the center. It's the bland fruit version of housing communities. That summer I had just turned 14. I listened to hip hop and tried to breakdance in my parents garage next to my mom's unused treadmill. My shoelaces were always untied, and my hair looked like I had just

been electrocuted. I was just an ordinary kid. But I had a secret itch.

I'd been admiring graffiti for a while, which seemed like fancy doodling on walls, except cooler because, well, it was on walls. I spent hours looking at graffiti writings in skateboarding magazines. I was itching to try it myself. I wanted to be the next Picasso of graff. One summer evening, an opportunity finally arrived in the form of a person eating Doritos. My friend Adi said that he'd got his hands on his older brother's spray cans. Adi's brother wore torn jeans and had greasy hair. He was the essence of cool, and he did graffiti.

Adi on the other hand, was not cool. Neither was I. But when Adi asked me if I wanted to go on a maiden graffiti voyage, I instantly replied "Aiight!" Which is 90s kid slang for "Yes."

So, there we were on the quiet streets of Suburbia. Adi with his backpack full of graffiti gear and snacks. And me, with a Ninja Turtles knapsack also filled with snacks, because we were 14. At sunset we decided to hit up the school.

On the way, Adi says to me: "You need a cool tag name". I blanked out. It was the same anxiety as when someone quickly tells you to "pick a number!" I kept thinking of words. "Is Cream Cheese a good tag name?" or "Chair? Chair One!" Nothing seemed to stick.

We arrived at the school and Adi handed me a blue spray can and a small bag of Doritos, because again, I'm 14. We went off. We spray painted lockers, doors, benches, toilets, floors and windows. The vending machine, because the school refused to stock Doritos in it. Screw that Vending Machine! This was Anarchy!

We sprayed until all our spray cans were empty and left proud and accomplished, feeling like we were the Bob Rosses of Brick!

On Monday morning I strolled into school. The art world had a bar mitzvah for me and I was now a man. In graffiti sense at least. Seeing Mr. Whitmore scrubbing away graffiti off the lockers.

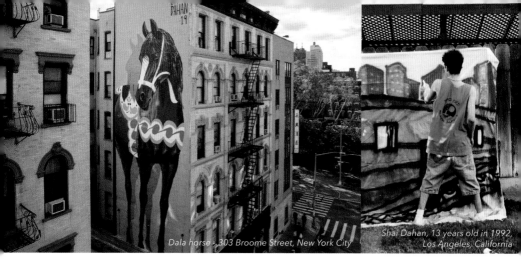

Dala horse - 303 Broome Street, New York City

Shai Dahan, 13 years old in 1992, Los Angeles, California

It was me! Nobody knew it, but I was a legend in my own head.

I sat down at the first class, in the back, because I self-proclaimed myself now worthy of a space in the back of the class! Shortly after the bell rang, vice principal Mr. Hernandez walked in with one of our school officers. Mr. Hernandez spoke with the teacher and then I was told I'm wanted in the principal's office. The entire class went "Ooooooooo".

I walked into the principal's office and saw the principal, Ms. McCarthy, sitting with my parents. Over the next few minutes, Ms. McCarthy became one of the most incredible detectives I have ever seen. She began by saying: "Shai, we know it was you who did all the graffiti," to which I replied: "I have no idea what you are talking about."

"BOOM! Take that Ms. McCarthy. You won't break me!" I thought to myself.

Ms. McCarthy looked unamused, turned to Mr. Hernandez and asked: "How does Shai spell his name?" To which he smirked and replied: "S - H - A – I." Ms. McCarthy then turned to the rent-a-cop and asked: "Mr. Perkins, what was the spelling of the graffiti tags on the lockers outside my office this morning?" He replied: "S-H-Y-Boy, mam."

I replied back: "That's not me. It clearly spells SHY and my name is SHAI."

Ms. McCarthy asked rent-a-cop once again: "Can you tell me what the graffiti in the boys bathroom said?" To which he replied: "S-H-A-I-Boy, mam."

I froze. In the excitement of my first graffiti ex-

perience, I blanked out and spelled my own name!

I was expelled from school immediately. My parents had to pay for the cleaning which made me do chores all summer. I wasn't allowed to hang out with Adi for the rest of the year either.

It's an embarrassing story. But it was my first introduction to painting on walls. Every artist in this book has their first story. Some are cool, some embarrassing. But we all took a leap into the world of public art and never looked back.

If it wasn't for Adi and his brother's spray cans, I wouldn't be painting murals around the world for a living today. My "Bob Ross on Bricks" moment made me who I am, and for that I'm grateful.

So, enjoy the following pages. Look at them as part of the artist's story. It's in the streets of our cities that the artists in this book find an unconventional canvas – a canvas that invites anyone with a vision to transform it into something remarkable.

It's in the realm of public art and street art that creativity truly takes flight, unburdened by the constraints of traditional galleries and museums.

I hope that from my story, you see that we can all learn to jump at the opportunity to create, as long as we respect the space that we're creating in. Respecting our communities while creating FOR our communities. Because at the end of it all, in street art, the work we leave on the wall is temporary. But the impact we make on our society is permanent.

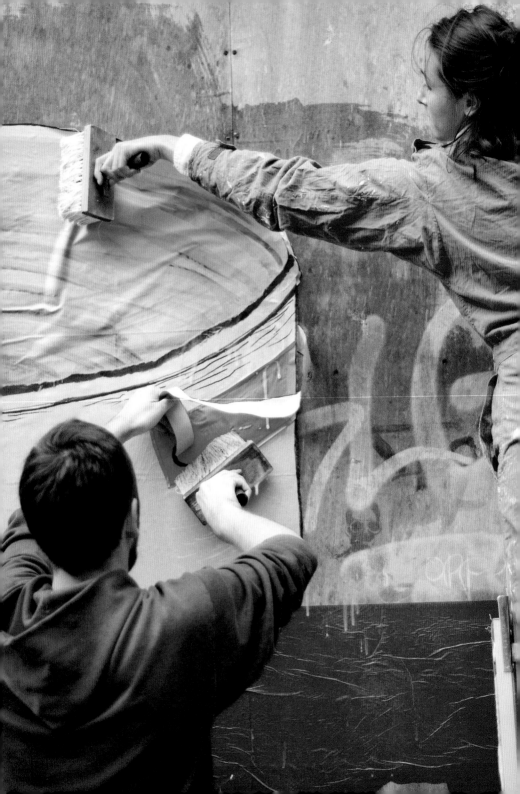

POSTERS

The poster has been advertising products, marketed events and brought political ideology to the public for more than two hundred years. Its strength lies in its real ability to communicate with people in public spaces.

For the street artist, it has the advantage of being prepared in the quiet of one's home, in the format best suited for the motif. It can be spread in large print runs, and it seems that many find it easier to digest a poster than tags, for instance. The poster is an established form of communication, and since paper breaks down sooner or later, it feels less criminal to paste one up without aut-

horisation. There are street artists who have exchanged the spray paint stencil for the poster in order to avoid fines.

The poster has been the main marketing tool for do-it-yourself culture, and its history is full of propaganda and calls to meetings and marches. When the photocopier began invading offices and schools in the 1960s and 70s, it became easier than ever to create your own concert posters, record covers and fliers. Clearly, many street artists draw inspiration from the alternative cultures of the late 20th century. Today, the poster dominates street art. And its forms of expression change constantly.

Gould och Various pasting the Rabotniki collage, Berlin.
Spread pp 10-11: Poster by El Bocho, Berlin.

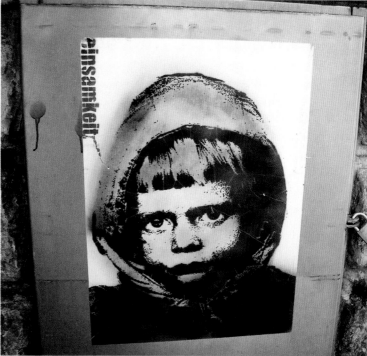

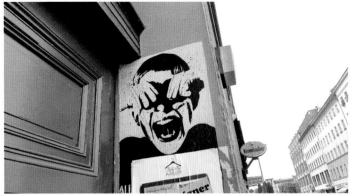

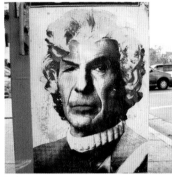
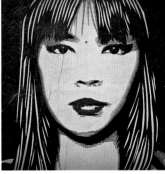

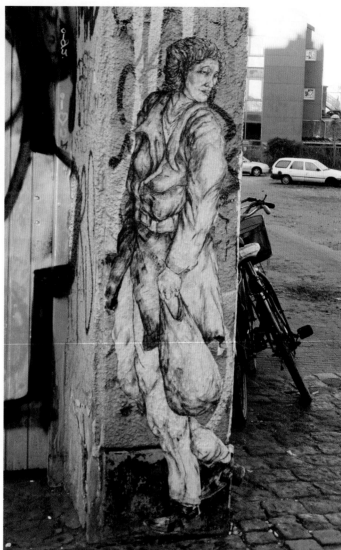

HOP LOUIE:

Make your own poster

MOTIFS

Poster themes can be created in several different ways: screen print, stamps, printers, photocopiers or spray paint stencils. You can also paint directly on paper. I write the theme on an A4 (approx. letter) and copy it onto overhead film. Then I put the paper up on a wall, project the theme with an OH copier and trace it in ink. Presto, I've blown up my work to the format I want. The marker pen should be waterproof.

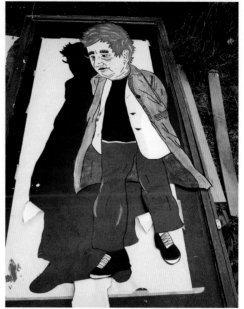

PAPER

A poster requires the right kind of paper. The thinner, the better. Thin paper sticks well and is harder to peel off. But if it is too thin, the poster will be fragile and will tear easily.

Art and graphics supply stores sell affordable rolls of paper. Unprinted newspaper stock is good and cheap. If you want a really good deal, shops like Ikea sell rolls of drawing-paper.

A good tip is to visit printer's shops and ask if you can have a look at their discarded material. I usually say I'm an art student working on a school project or something similar.

When I make large posters, I join the sheets together with paper tape that sucks up the adhesive. To avoid the paper crinkling, I tape the poster to my working-table.

PAINTING

I fill the parts I want in colour with a thin layer of acrylic paint so that the paper still can suck up the paste later. The paint should be waterproof for the illustration to last a few years. I test this by painting on a piece of paper, letting it dry, and then rubbing around it with some water.

CUTTING

A poster with a different shape sticks out and attracts more attention. Sometimes I make a so-called cut-out by cutting the poster out. I use a scalpel, but a knife or scissors work too. Place the posters on top of each other and cut several out at once. When finished, I fold it up for transportation.

PASTE

Cheap wallpaper paste mostly works better than expensive. Mix the powder little by little in room-temperature water while stirring. I keep stirring it for a while after it starts to feel thick. If it gets too thick, add more water and stir. The result should be treacly and gelatinous.

By mixing in different ingredients, you can make paste that is more durable or shiny. Wood glue en-

sures that the poster sticks better. A little varnish can make it shinier and resistant to rain.

If it's below zero outside, I pour in a little salt to keep the paste from freezing. Alcohol or methylated spirits have the same effect.

BRUSH OR ROLLER

Paste the poster up with a brush or roller. If the brush has metal parts, they will rust if you don't wash and dry it after use. Rust can leave brown patches on the poster.

TRANSPORTATION

I use a plastic bucket for the paste, the right size for putting in a plastic bag. That makes it easy to pick up the brush when the time comes. I carry a stack of posters in a bag. The rest are in my backpack, properly folded in a plastic folder. My backpack also contains extra paste, water to wash my hands in and a towel. You easily get messy. However, wallpaper paste is just starch and water, and can be removed with water.

PASTING UP THE POSTER

Wallpaper paste works well on most surfaces. You quickly learn how much to use and the easiest way to paste the poster.

I use plenty of paste on a clean, smooth surface, large enough for the poster. Then I unfold the poster and press it to the wall. The poster can now be adjusted carefully, but it's a bit fragile when it's wet. Once it's nicely in place, I get more paste and brush it on from the middle of the poster out towards the sides. It's important to saturate the sides with paste, otherwise they can roll up when it dries. I use both the brush and my hand for flatten lumps and bubbles. The smoother the poster is pasted up, the longer it will remain. Sometimes I cut the corners of the poster. You can't see it, but it makes it hard to pull it down.

The paste needs a few hours to dry. With large posters, you might need several people to help you.

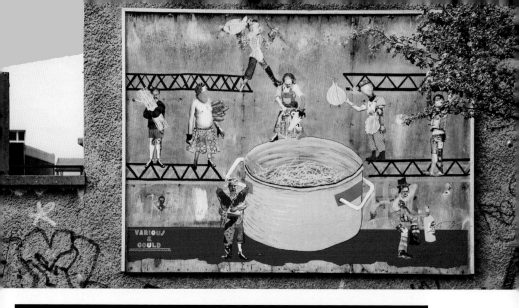

VARIOUS & GOULD:

The Rabotniki project

Various and Gould are two Berlin street artists who often work together. Here they present one project and their own recipe, since one shouldn't work with art on an empty stomach.

THE RABOTNIKI PROJECT

The Rabotniki (Russ. for workers) are part of our new series of silk screen collages. It's all about work. Work nowadays is becoming increasingly invisible, and harder to grasp and comprehend.

The components for our collages are employees, labourers and especially construction workers. In times where paid work is short and physical work is being taken over by machines, we want to celebrate the worker, the "dinosaur" of our time

COLLAGES

Collages are a way for us to work as a team. We agree on a theme and the size. Then we search for body parts and draw, swap, scan and overwork them on the computer. Everything is screen printed on various types of paper and cut into pieces and reassembled into figures.

CUT OUTS

Working with cut-out figures means you're not only bringing a picture to a public place, but you can also change the whole place into a picture. Figures in separate parts give us the flexibility to work with the space, by installing and putting the pieces together right on the wall.

MATERIAL

We love paper, not only because it´s so great to combine, but also regarding its transience. The diverse kinds of paper all behave differently, depending on their wood content. Some go yellow, others go pale. Bit by bit, pieces fall off so that in the end maybe only a face and a shoe are left.

16

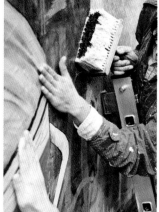

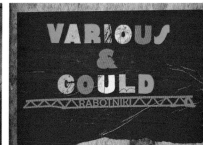

Spaghetti à la Marseillaise by Various & Gould

*"Cooking and eating in good company, exploring ideas
together and trying out new things
– all this is fundamental to creating good art."*

Ingredients for 4 persons:

2 aubergines/eggplants
1 can of anchovies in oil
Fresh rosemary
1 onion
1 clove of garlic
1 jar of small capers
Olive oil
Parmesan
(you can never overdo it!)
1 packet spaghetti
1 lemon
2 teaspoons tomato puree
(White wine for sauce)
1 bottle Pastis (aniseed liqueur)

Put the aubergines in the oven whole. Bake until they are soft (20-30 minutes) and they whistle and steam like a locomotive when you puncture them. Leave them to cool down or run under cold water. Then cut off the stem, peel and cut into chunks. Cut the anchovies into pieces as thick as your finger. Chop the garlic and onions and sear in a frying pan with hot olive oil together with a handful of capers, the anchovies and the rosemary. Put the eggplant in an extra bowl and puree together with a good dash of olive oil and some lemon juice. Add to the pan and let it simmer. Dissolve tomato puree in half a cup of warm water and stir into the rest. Finally, taste with salt and pepper and a splash of white wine. At the same time cook the spaghetti in boiling salt water with a dash of olive oil for 10-12 minutes. Afterwards, strain and rinse with cold water and mix with the sauce in the pan. After serving, put grated parmesan on top. While and after cooking, drink lots of Pastis.

Bon appétit!

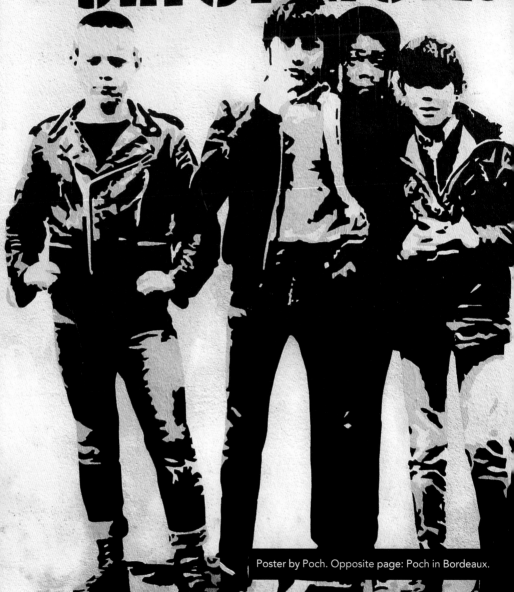

JEUNES SEIGNEURS

Poster by Poch. Opposite page: Poch in Bordeaux.

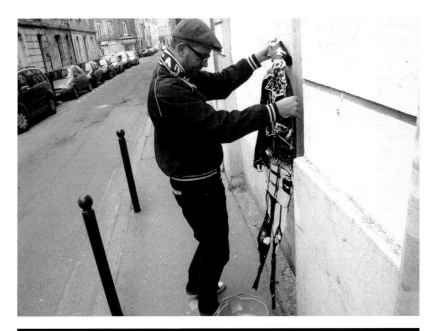

POCH:

Collages that interact with the passers-by

Poch has been established in the Parisian street art scene since the mid-1980s. His influences stem from graffiti and the punk environment he grew up around and was active in. After working with spray paint stencils, he began developing large, graphic and stylish posters.

Why do you paste up posters in the street?

I create the collage of the street, and it's an evident continuation of my previous graffiti work. The poster allows me to make really large works, which would otherwise be hard to do directly on the walls. I've always been interested in concert posters, and make collages that look like advertisements for my own made-up rock group. And I often do works with celebrities – it creates an interesting and different interaction with the viewer.

What are the pros and cons of posters?

It gives me time to prepare complicated works. But problems also arise. In addition to the difficulty of finding the right spot to place the poster, my paper is often thin and fragile, and when the wall doesn't complicate matters, the wind does.

How do you get hold of your materials?

I collect the large paper rolls they print local newspapers on. They are free and can easily be pasted to the wall since they are thin.

When do you paste your posters up?

I paste both night and day, it depends on the spot. My friend Josephine often hangs along to take photos or keep a lookout.

SWOON:

City walls as public sounding board

Swoon started making street art in 1999, and is known for her life-size cut-out posters of people. She has taken poster art a step further by gathering inspiration from Indonesian shadow puppet theatre, amongst others. Swoon is a member of the art collective Justseeds.

How did you start?

Getting to New York was a huge shift for me from the life of a small town. I started to notice people who were working with the city in all kinds of different ways. At first I just wanted to be a part of that collage of information, so I started postering little transparent collages. Then I started working with the ad spaces in the subway, and from there I was working with the walls and postering.

What attracts you to work in the streets?

I love the layers, the natural beauty of a thousand coincidental markings and factors. At the time it seemed like the street was the only place where real beauty was occurring. The only place open to spontaneity.

How do you work?

I usually do life-size portraits of my family, friends or people I see in the neighbourhood. I get fixated on a gesture or expression. I take lots of pictures and collect hundreds of images from the library, which are a huge body of inspiration. I use a few different techniques, from just cut paper to linoleum or wood block printing. All of the portraits start out with a rough sketch and then if it's paper cut, I refine the drawing down with a knife in a few layers of paper, if it's a block print then I carve it out, and

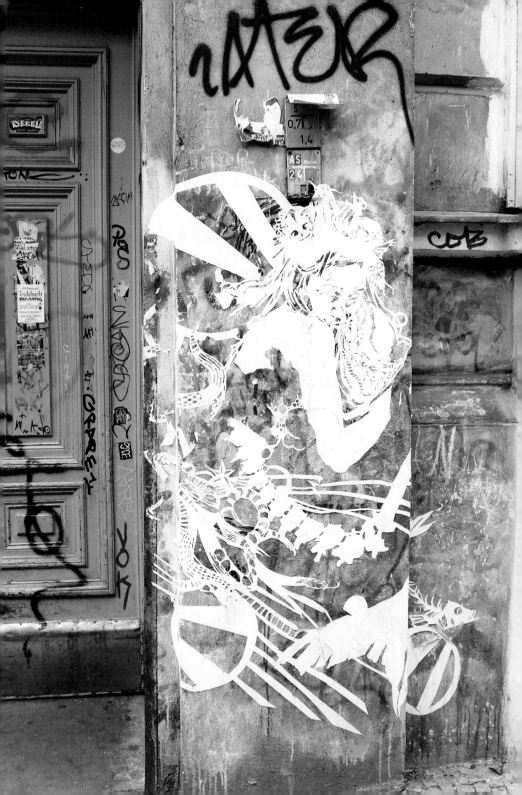

Previous page: Swoon in Berlin.
Gould & Various: instagram.com/variousandgould
Poch: instagram.com/patrice_poch
Swoon: swoonstudio.org

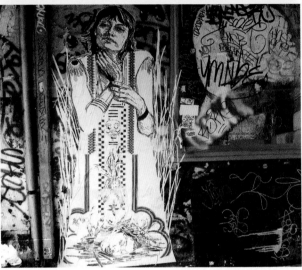

I print it by inking my block, laying a large sheet of paper across the top and walking all over it. Then I just wheat paste them up outside, roll them out like a very fragile piece of wallpaper and see what happens next.

From drawing stage to finished piece, the paper cut outs take about a week, the linoleum and wood block prints maybe two weeks.

How do you feel about doing something that's considered illegal?

I think the walls of cities should be a public sounding board, a sort of a visual commons. If the joy that it brings to me and to others outweighs the potential damage, then I don't feel conflicted. The prankster myth is valuable here. Throughout history, pranksters have been looking at fences and then pushed them aside. The boundary between public bulletin board and private real estate investment is thrown wide with a gesture as tiny as a marker tag. It's almost like a magic trick.

Where do you prefer to put up your work?

I'm in love with the liminal, third-space, left-over parts that are often right in the middle of the most vital parts of the city. Advertising is always trying to place itself a million miles above us, just out of reach like the rest of it's promises. I find myself trying to work at eye level, where people are walking and to depict the life that exists here at the bottom edge, our ordinary reality.

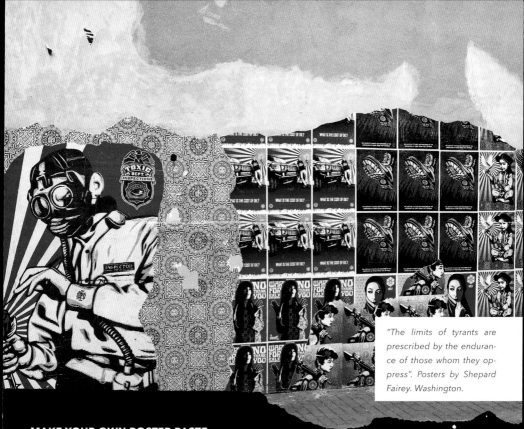

"The limits of tyrants are prescribed by the endurance of those whom they oppress". Posters by Shepard Fairey. Washington.

MAKE YOUR OWN POSTER PASTE

For making your own poster paste you'll need:

- Potato flour *
- Water
- Sugar
- A large saucepan
- Something to stir with
- A bucket or similar to keep the paste in

Mix one part flour to three parts water. Pour the water in the pan, then measure out the flour and pour in a little at a time. Stir it properly so the flour doesn't form lumps. The smoother the paste, the better. A tablespoon of sugar makes the paste stickier.

Once everything is mixed, put the pan on the hob and bring to theboil as you continue to stir. After a while, the mixture will start to thicken, and when it's thick enough, remove the pan from the hob and let it cool. The paste should now be viscous. When it has cooled, pour it into a bucket.

Many people experiment with their own ingredients. If you're pasting up on unvarnished wood, it might be a good idea to mix in wood glue. Use about half as much glue as paste.

* Some people use rice flour.

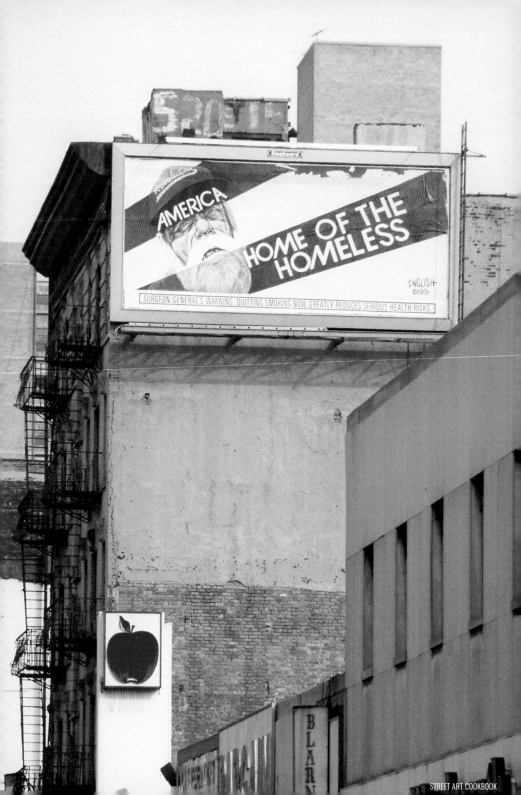

ADBUSTING

Adbusters enter the battle for our attention by changing the messages of advertising.

Since the 1970s, the San Francisco-based Billboard Liberation Front has hijacked billboards around the US, and are the pioneers of the movement. The organisation Adbusters exists in Canada since 1989, and their magazine of the same name is distributed in large print runs worldwide. Adbusters organise campaigns like Buy Nothing Day and TV Turnoff Week.

The tactic, often known as Culture Jamming, focuses on interfering with, distorting or transforming commercial messages and logos. Its influences include the medieval carnival were power was overturned, the Situationist critique of consumerism and Yippie happenings. Naomi Klein's book "No Logo" has also been most influential.

Many street artists work in this tradition and question, directly or indirectly, who has the right to communicate in the streets and squares of the city.

Ron English in New York.

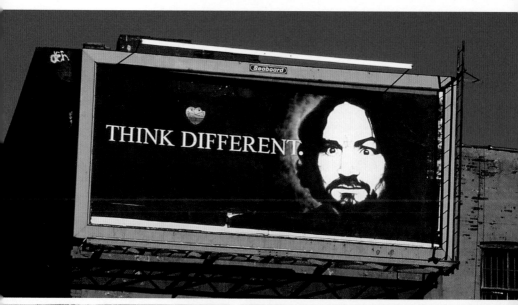

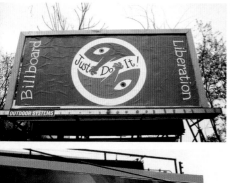

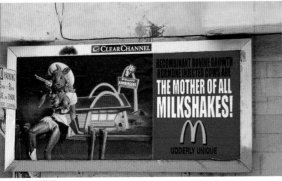

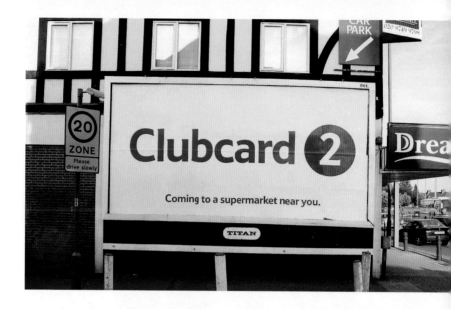

DR D:

Go out and change something in the real world

Dr D started adbusting after reading Naomi Klein's "No Logo" in 1999. The letters "Su" disappeared from one billboard, reappearing on another, transforming "Suddenly everything clicks" to "Suddenly everything sucks". Since then, he has been editing advertising in the Greater London area by cutting and pasting boards and posters.

Which techniques do you use?

Large paper prints from scanned collages of images from other media is a quick way to get something intricate up on a wall. All you need is a wallpaper paste, a brush, a knife and a ladder. Coming up with an angle on the ad is the difficult part. My hint to a beginner: don't spend time watching TV, go out and change something in the real world, It'll make you feel like you exist for once.

How do you prepare yourself?

Getting equipment ready for any eventuality: knives, drill, gaffer tape and cable ties, etcetera. Then I stick some hip hop on the van's stereo as it helps me to get you in the mood for being naughty – I'm talking about NWA or something like that.

How are you able to work without being disturbed?

If you look like you're supposed to be there and do it with balls you'll get away with murder. Get a hi-visibility jacket on and put some barriers up and you disappear into the background of city life. Wear a uniform and you slip under the radar.

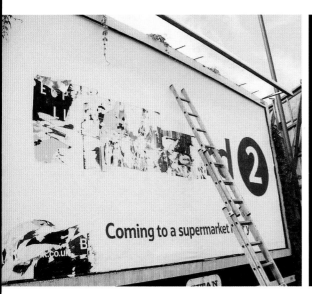

DR D'S THREE STEPS TO A SUCCESSFUL PROJECT

Find a nice bold board that you can rearrange the lettering on.
Find the same board in another location and cut the lettering from it.
Go back to the first board and put up the rearranged letters. To restick the letters you have to tease back the paper so you are left with the thinner top layer of the poster only. Once it dries out it'll look like it is part of the original board.

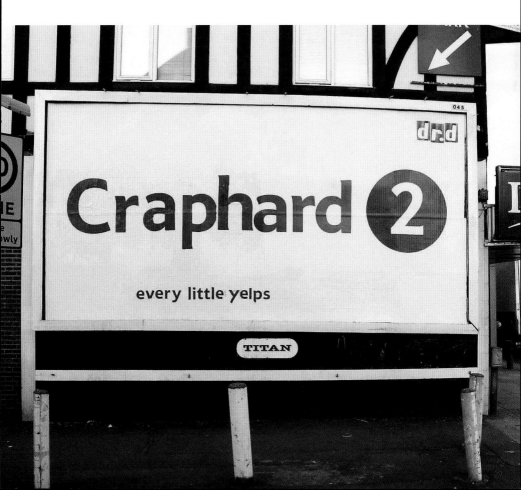

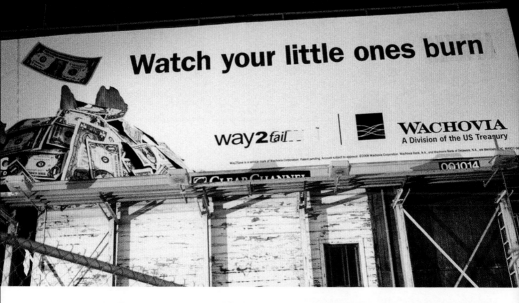

JACK NAPIER:

Everyone should have their own billboard

For more than twenty years, The Billboard Liberation Front in San Francisco has been conducting something of a guerrilla war against the appropriation of public space by advertising. Jack Napier (an assumed name), one of the organisation's founders and its spokesman, relates his experiences.

What's the point of liberating billboards?

Billboards and other visual media such as posters on subway trains and buses are the one type of media that you have absolutely no choice about encountering. Advertising is the language of the culture in the USA and to a slightly lesser degree in Europe. The thing to do is to use the language of advertising to make your ideas known. Since billboards occupy the common space that we all inhabit, they must be common property. Everyone should have their own billboard

with which they can communicate with the world.

It seems like you do a lot of planning before you hit the streets.

We've used tactics often to good effect. For one project, the "Land of the Blind" billboard, we had a French TV crew following us around. We set up a "video shoot" on a traffic island about one hundred feet away from the billboard we were altering. We had pretty girls dancing on the island with big lights shining on them and two big professional cameras mounted on tripods. Everyone who drove by, including the police, looked at the girls and the cameras. They didn't look at the billboard where three of our men were changing the sign. We told the French TV crew that if the cops caught us we would say the whole thing was their idea!

How do I put my work up?

Choose a spot that you can get on. Some

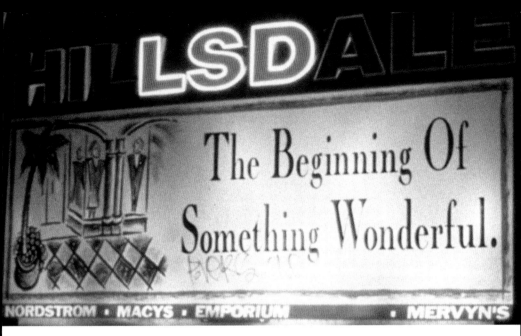

are very close to the ground and relatively easy and safe to get on. Some are massive and very high above the ground. Start small and safe. Use a panel affixed with two face tape or spray adhesive that will allow the alterations to be easily removed.

What do you tell people who says this is illegal?

I tell them to talk to my lawyer. The BLF doesn't damage the billboards that we borrow. We go to great pains to make images and paste-overs that can be easily removed without damaging the underlying billboard. We also leave instructions for the sign company employees on how to best repair the changes we have made. And we leave a very nice bottle of Scotch whisky for the workers as well. They like us.

There's a lot of humour and irony in your work.

If you go up on a billboard and write "Fuck Exxon" or "The Government sucks" no one but dull people that already agree with your dull ideas will take any notice. If you say something like "Nine out of ten people agree that eating poop is bad for your teeth", then you're really making a statement!

FIVE TIPS FROM JACK NAPIER:

1 Find a billboard that has a message that you must change.
2 Gather your friends, promise to supply them with alcohol after the action.
3 Go to the billboard, measure the letters and take colour samples.
4 Make drawings of what the finished board will look like.
5 Survey the area. Find access to the board and escape routes for when you are leaving.

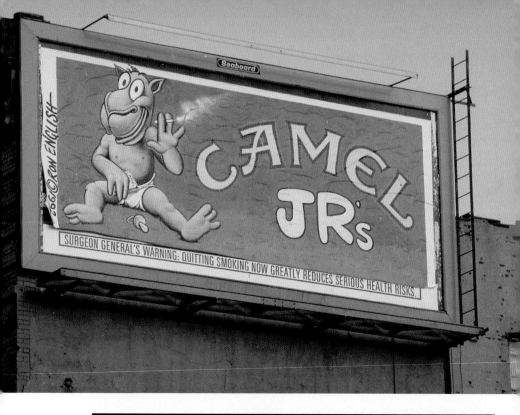

RON ENGLISH:

Dangerous, illegal and redeeming

Ron English is a pop artist who lives in New York. He has been changing billboards since his college days, and has inspired countless street artists over the years. English is one of the founders of the Culture Jammers movement, and his most famous work is probably The Cancer Kid, which was part of a campaign in which he questioned tobacco companies' advertising to young people.

How did you get involved in liberating billboards?

I was caught in a traffic jam looking at the billboards when I noticed they all had ladders that came down to 15 feet from the ground. If I got a 15 foot ladder the billboards could be mine and the traffic jam would be my art gallery.

What's your message?

Free speech. And it's not free speech if you have to pay for it.

What do you tell people who point out that this is illegal?

Call the cops.

What's your best argument for adbusting?

Public space is a human right. If advertising works, it follows that anti advertising would also work.

What are the responses from the passers-by?

They love it. I don't think people are that fond of billboards.

Which techniques do you use?

My materials are the same as the billboard company's. I work during the day so I don't seem suspicious.

How do you choose the spots?

You can get a list of available billboards from the billboard company. The available billboards will still have ads but the contracts on the ads have expired. This helps when you go to court after being arrested.

What should I think of as a beginner?

It's dangerous, illegal and redeeming.

How do I avoid getting arrested?

Work fast. Make sure your billboards look professional. Pray.

Ron English: popaganda.com
Dr D: drd.nu
Billboard Liberation Front: billboardliberation.com
Poster Boy: flickr.com/photos/26296445@N05

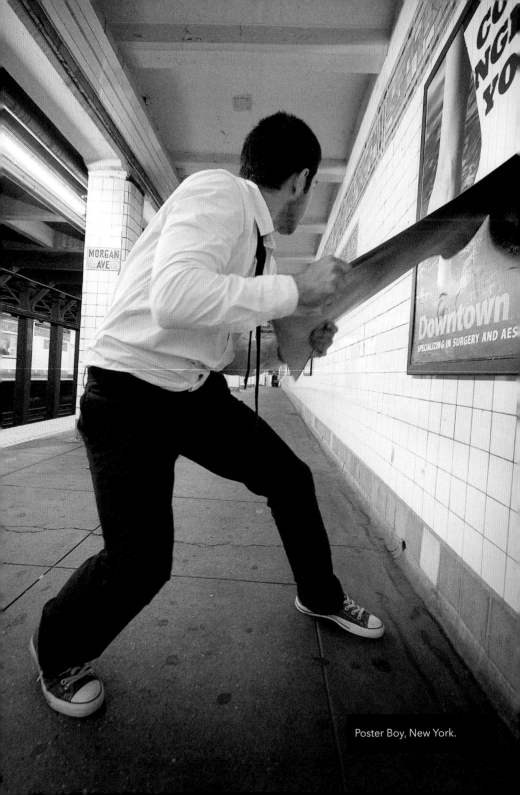

Poster Boy, New York.

POSTER BOY:

Laws are imperfect

Poster Boy lives in Brooklyn, New York, and uses a razor blade to alter advertising. When he discovered that many subway posters are printed on self-adhesive paper, he started cutting parts out in order to create new works. The results are powerful and satirical collages. Poster Boy has been called "The Matisse of subway ad mash-ups". The Poster Boy Movement, moreover, is a movement in which other artists make unsigned works in the same spirit.

What should I think of as a beginner?

Beginners should pay close attention to their surroundings, the political, cultural and physical environment.

1. Read
2. Travel
3. Question everything

Why do you work illegally?

Laws are man-made. In other words they're imperfect and subject to change. Laws are usually put in place to protect the haves from the have-nots. Advertisers have a voice that I have not. Public advertising is unavoidable, unlike a magazine where ads can be flipped or television where channels can be zapped. I'm just flipping and zapping the commercials I don't like.

SPRAY PAINT STENCILS

The spray paint stencil is popular among street artists. It's simple to produce and reusable. It requires a bit of work if you want to work with larger formats and in several colours, but in principle you need little more than an idea, a sharp knife, paper and paint.

The spray paint stencil, or portable printing press as it's also known, is therefore very suitable for someone who wants to get his message out at little cost.

Unlike posters and stickers, it can be used on the most varied materials, and interacts with the background in a graphically powerful way – the theme becomes a natural part of the surface.

The roots of the spray paint stencil can be found in Egypt and China, but its modern form has mainly been used for political pro-paganda. The 1968 Paris revolts, the 1970s Sandinista portrait of Sandino in Nicaragua, and the anti-apartheid movement in South Africa are a few examples.

The technique got second wind when Blek le Rat used it in the streets of Paris in the early 1980s. It was also much used by Punk bands in the 1970s and 80s. In later years, Banksy's stencils have become something of an icon of street art.

Urban walls are rife with images from popular culture: film stars, comic-book cha-racters, musicians and video games. A fixa-tion with faces is prevalent, but objects also appear: TV sets, flowers, or animals. A lot seems similar. Che Guevara, George Bush, gas masks, weapons, rats and skulls are well represented. But many experiment and take the stencil further.

C215 paints in Venice.

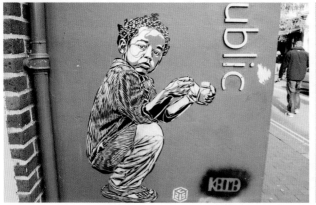

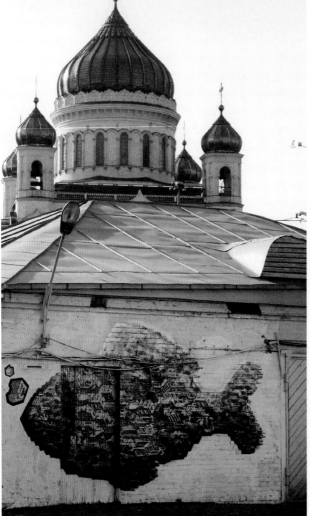

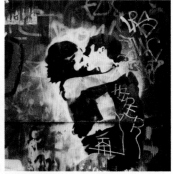

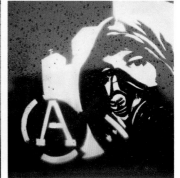

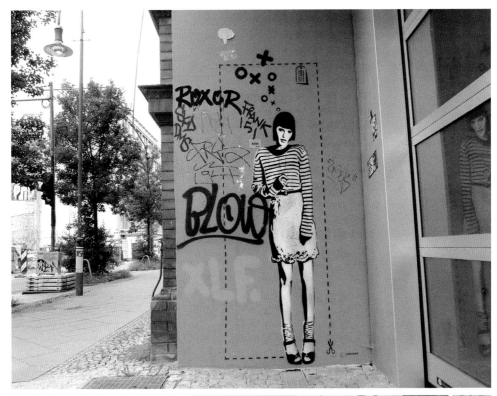

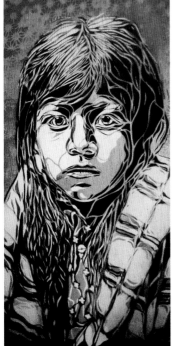

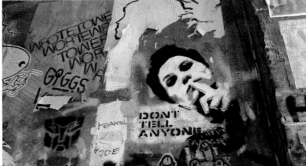

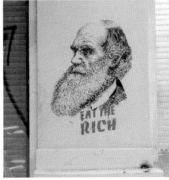

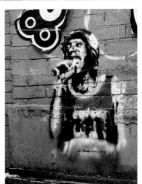

HOP LOUIE:

Make a spray paint stencil

My first spray stencil looked like shit. But practice makes perfect. When I'd done my first stencils, I noticed it's the idea that needs the most time and thought.

Before starting, it may be an idea to check out what others have done. There's a lot of inspiration to get from the internet and books.

THEMES

You can make very simple stencils to advanced multi-coloured stencils in several layers. Start with a simple motif with high contrast and clear contours. You can take the image from a picture or photo, draw it by hand, copy it or produce it on a computer. Some people find it more authentic to work without a computer, but programmes like Photoshop and Illustrator have made it a lot easier for me.

MONOCHROME PHOTOSHOP SPRAY STENCIL

Step 1. Open the image. Go into "Image – Image size" and make sure the resolution is 300 DPI. Otherwise the picture will get pixellated when you edit it.

Step 2. Make the image black-and-white by choosing "Image – Mode – Grayscale". In Adobe CS3 and later versions you can also choose "Image – Adjustments - Black & White."

Step 3. I increase the contrast on the black-and-white picture to remove all grey tones. Then I go into "Image – Mode – Brightness/contrast", and increase "Contrast" to 100% and adjust "Brightness" to whatever fits the image. Sometimes I repeat this step a few times to get sharp contrasts between black and white.

You can also choose "Image – Adjustments – Threshold", but I don't feel I have as much control over the image then.

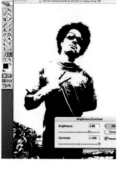

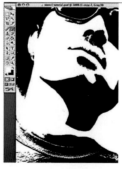

Step 4. Time to simplify the image. I erase everything that shouldn't remain on the image and fill in where needed. You should be able to cut out the black parts. Anything that looks too small should go. The straighter and simpler the lines, the better, at least for a beginner.

Step 5. Time to build cross-links, or bridges. Their role is to hold the details of the stencil together. You have to be careful here to avoid cutting out important details.

Step 6. I save the stencil as a layer and print it out in the desired size.

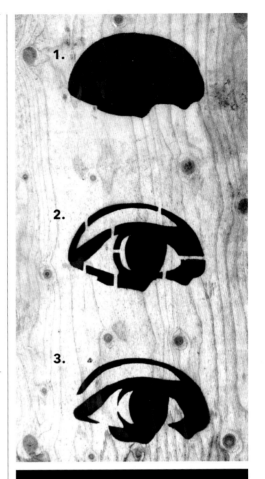

CROSS-LINKS

1. No cross-link: The image has no cross-links to keep the stencil together, so when I cut out the black parts, the white parts come off too.

2. Simple cross-link: Here, I have created simple cross-links, so the white parts stay, but it doesn't look natural.

3. Better cross-link: In this example, I have changed the image so the links become part of the design. I always go through the finished image carefully and check where I need to make links.

MULTI-LAYERED STENCIL

If you are doing a stencil with several colours, you use one stencil - one layer - for each colour. This is how I make a polychrome stencil in Photoshop. It's just like a one-layer stencil, with a few exceptions.

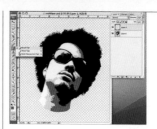

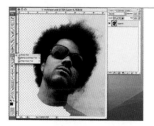

Step 1. I open the image and make sure the resolution is 300 DPI in "Image - Image Size - Resolution". Then I erase the background so just the image is there. The simplest way to do this is by using the Eraser tool.

Step 2. Now I increase the contrast and Brightness by choosing "Image - Adjustments - Brightness/Contrast". I increase it a lot, since I want sharp contrasts between colours. I often repeat this step a few times.

Step 3. I then go into "Filters - Artistic - Cut Out" to simplify the lines further. I push the sliders a bit to see how the image changes. "Number of Levels" may be the most important, this is where I adjust the number of colours I want in the stencil.

Step 4. When the image has been simplified, it's time to make the lines straighter and give it the personal touch. You should think of the printing size. The bigger it is, the more details you can work with. I use the Brush tool and make a new empty layer where I paint in the colours that are already in the image. Once I've chosen the brush, I press "Alt" while clicking on the colour I want to use. That automatically selects that colour in the palette.

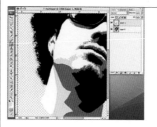

Step 5. Adjust the image to your taste. I usually make all the choppy lines straight and smooth.

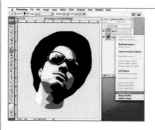

Step 6. Once I have the image I want, I put the layers together. The simplest way to do this is to go into "Layers - Flatten Image".

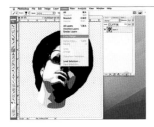

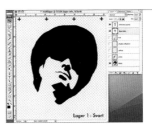

Step 7. Then I use "Select – Color Range" and choose one colour at a time. When one colour is selected, I create a new layer at the bottom of the layer window with the little tab next to the recycle bin, marked with a yellow circle in the picture. In the new layer, I fill the selection with black as the foreground colour and press "Alt + Backspace". Now this layer is separate from the others and is black, which is good for printing on a black-and-white printer.

Step 10. To get the different layers to fit well, I make a few register marks on a new layer in Photoshop. I allow these to stay when I print the layers. Then I cut out all the black in all the layers, including register marks.

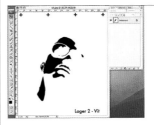

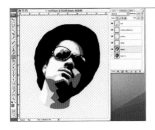

Step 8. I repeat the procedure until I have a separate layer for each colour. I rename the layers to keep them organised.

Step 11. By clicking on the eye to the very left of the layer in the layer palette, I hide all the register marks and all the layers except one. Then I save the layer as a jpeg, with a unique name, for instance "layer 1 black". When you save a Photoshop file with several layers as a jpeg, it becomes a new file without layers with a white background. That's good for printing. Then I change the name in the text layer to "layer 2 white" and repeat. When I have saved every layer as a separate file, I'm ready to print.

Now I attach my images with spray glue to the sheets of cardboard where I'm going to cut my stencils. I cut out layer by layer, starting with the register marks in case the glue loosens.

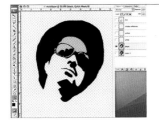

Step 9. Here, I check through every layer and look for layers that need cross-links.
See cross-links under 'Monochrome stencils', previous spread.

MATERIAL

The material for the stencil should be strong, but not too hard to cut and produce details in. Some use advertising boards, others pizza boxes. Overhead plastic laminate or the plastic that covers newsstand boards also works. Plastic is good for smaller stencils. You can get the materials at well-stocked stationers', but that's not as fun as finding it for free. Different materials last differently. A thin paper stencil can only be used a few times. Thick paper, cardboard or plastic last longer. Experiment! We probably haven't found the ideal material yet.

MAGNIFYING

You can make images almost any size. You can subdivide them into several A4s (approx. letter) in Illustrator or InDesign. Go into "Fileprint – General" in the lower right-hand corner box. Choose "Tile" and allow the scroll list to remain on "Full pages". I choose a few millimetres in "Overlap" to make it easier to puzzle the picture together.

After printing, glue the image to the material you are going to cut. It's important to glue the whole back of the paper and let it dry properly. It's a hassle if it gets loose and you no longer know where to cut. Wallpaper paste is good. Spray glue is my favourite, but expensive. Stick glue works, but is unreliable.

Personally I print my images in a small format and copy them onto overhead laminate. This is easier with a projector for the computer.

For a larger stencil, I tape sheets of cardboard together. Gaffer tape is both supple and strong. Three A1 (approx. 23 x 33 inches) sheets produce a stencil about the size of a fully-grown person. I like thin cardboard, but not too fragile, because it has to withstand folding and transportation.

I tape the paper to the wall and adjust the overhead projector so that the image doesn't go

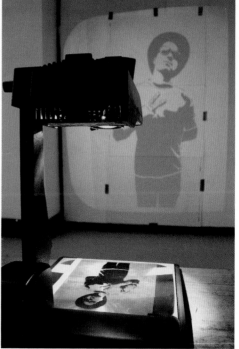

With an overhead the image is projected on the stencil.

too far out on the sides. That makes the stencil more durable once it has been cut out. Then I trace the image with a pen.

CUTTING

I use a small cutter of the sort that you can feed new blades with. They can be found in economy packs in department stores and are quite cheap. Otherwise, a carpet knife or scalpel works.

A stencil takes longer to finish than you think, and my fingers often ache for days afterwards. But it passes. The sharper the knife, the nicer it is to cut with. I would rather use several cheap knives than one expensive one. I break off the end with a tong as soon as it feels the slightest bit blunt.

Make sure you have a stable underlay to cut against. Both a cutting board and cutting mat work. But you will only use the board until you have found a mat where the knife doesn't pierce or get stuck in. I cut as carefully as I can, following the contours of the image. I'm always ready to improvise a cross-link.

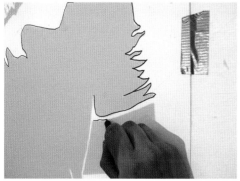

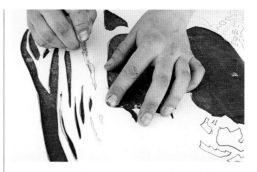

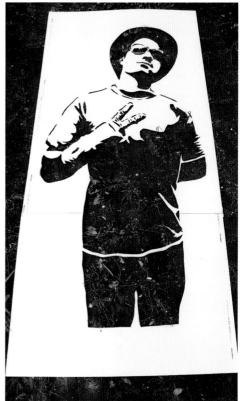

Draw along the outlines of the projected image.

The alternative is not to improvise, but triple-check all the links before cutting.

It's easier to cut a large stencil than a small one. The details are less fiddly, and it's easier to see what the image represents. So it can be good to start in A3 (approx. tabloid). The theme can be divided into two parts, each printed onto an A4 and put together. Or print it out on A4 and magnify to A3 in a photocopier.

You can divide a sheet cardboard box into several small stencils that can be painted up one by one. Or do what I do and tape several sheets together into a big one that can be folded.

TESTING

I test the stencil by spraying it against a piece of paper. I press the stencil against the paper, either with my hand or a stick, and spray carefully, about 30 cm from the image. When the paint has dried, I take out a pen and mark the parts that don't look good on the stencil. Then I can correct the details as needed.

TRANSPORTATION

When the stencil is ready, I fold it together. It's best to use a folder with hard sides large enough to hold the stencil, or it can get stuck and tear. You can buy the classy kind in an art supply shop. The less classy kind is made of cardboard and gaffer tape.

Of course, you can carry a small stencil in a paper bag. A classic, used by the Punk group Crass in London in the early 1980s, was to make a stencil in the bottom of a paper bag. Place it in the right spot, spray, and move on. Others cut the stencil out in the bottom of a pizza box. I even heard about a guy who wears two layers of clothes and carries the stencil between them. Probably gets pretty messy.

Large spray stencils have many advantages, but are hard to transport. Remember the stencil can get sticky and tear if it is folded before it has dried.

PAINTING

I attach the spray stencil against the surface with gaffer tape. I usually carry a few bits of tape on my shirt or the inside of my jacket so they are quickly available.

The spray can has to be shaken a bit and then used about 30 cm from the image. If you spray too long, it starts to run. You can always press the stencil to the surface, that makes the image sharper. I wait a few minutes before taking the stencil down, but there's no point in standing around too long next to a wet stencil.

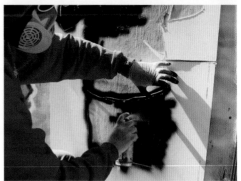

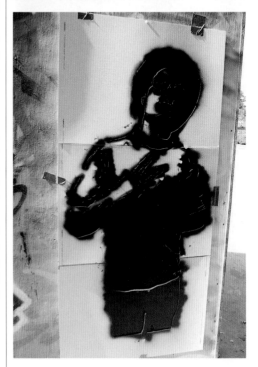

Some people are terrified of anything that has to do with spray cans. And that makes them do strange things, like attacking someone who is painting on a wall, whether it's legal or not. A glove around the can mutes the noise. A magnet at the bottom of the can stops the ball from rattling.

I always bring more caps, nozzles, than I had planned to use at first. And I carry everything in one bag that I can just throw away.

It's a good idea to paint the first stencil in peace and quiet. Once you've got started, it's time to look for interesting spots. The right spot makes the stencil look better.

PAINT

Most artists have their favourite paints. In Europe, many people use Belton or Montana. I think Montana Gold works nicely for stencils in several layers. The fastest-drying paints are "flat", "ultra flat" and "satin". They make it easier to spray on a second colour quickly.

The choice of cap is individual. I often use fat caps with high pressure for large surfaces and thinner, soft caps with less pressure for smaller or more detailed surfaces. Skinny caps, which many graffiti writers use for precision jobs, are seldom suitable for spray stencils.

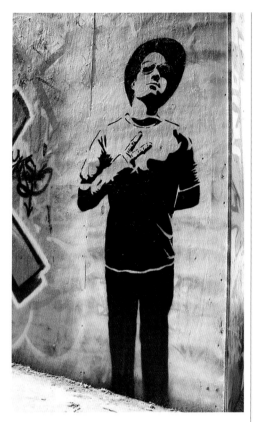

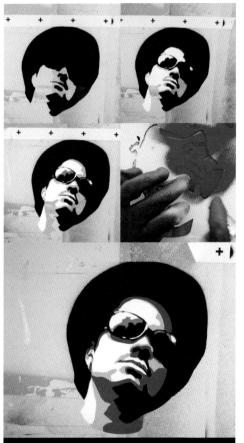

PROTECTION

When I'm going to paint a lot I use a face mask, preferably a real gas mask that covers both the nose and mouth. I change the filter when it starts to get coloured. That way I keep a few brain cells and won't risk getting a headache. Single use masks and mouth protection are better than nothing, but they only filter paint particles. I don't paint indoors, and let what I paint outdoors dry for 24 h before bringing it in.

Single-use latex gloves protects the hands from paint. With turpentine and a rag most paint stains are easily removed.

"If I have a polychrome stencil in layers, I first tape masking tape on the surface. These will be my register marks when I paint the first layer. Then it's easy to adapt the following layers to the first, so the stencils fit. Then I carefully make sure that the paint dries between layers. Then I pull off the tape with the marks."

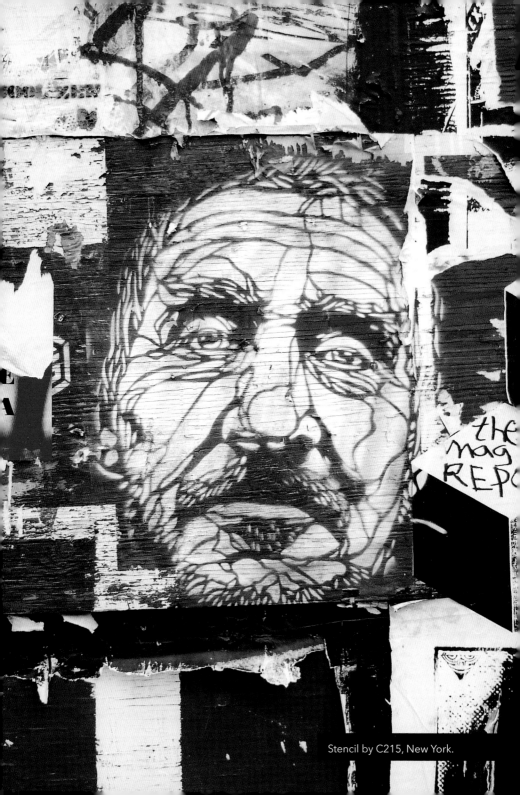

Stencil by C215, New York.

C215:

I'm just a stencil artist and I love it

C215 from Paris has developed a characteristic style that has gained him admirers worldwide. His detailed spray stencils seem almost photographic. C215 is something of a nomad, and gets inspiration from the people he meets in cities like Paris, Casablanca, New Dehli, Dakar, Sao Paolo, Amsterdam and Istanbul.

Why paint in the streets?

They're just my favourite gallery. I've been in love with graffiti since I was a child. I have painted free hand, with brushes, with cans and so on, but stencils are the best way to create something beautiful anywhere in the streets, without any authorisation.

How would you describe your development?

I've been drawing a lot since I was a kid. I now have a Masters in art history, so the influences are really hard to define. For me the founder of street art is Ernest Pignot. Ernest stays for me as the best artist of the century.

Do you work with different styles and themes in different countries?

For me travelling and painting is the same. I always compare street art to surfing. If you stay on the same beach your whole life, surfing the same wave, you're a loser. And context is the most important thing in street art. There should be a stencil for each situation. Reproducing the same stencil everywhere should be boring.

You use a lot of faces as motifs.

I paint in the streets and I paint people who belong to the streets: tramps, beggars, street orphans from the poorest countries. And faces reflect personality. You can read a full life on a marked face. This is a stencil tradition by the way.

I guess that a lot of people never meet tramps because they don't pay attention to them. Tramps have fascinated me for a long time. You have to be very courageous to accept such a tough life.

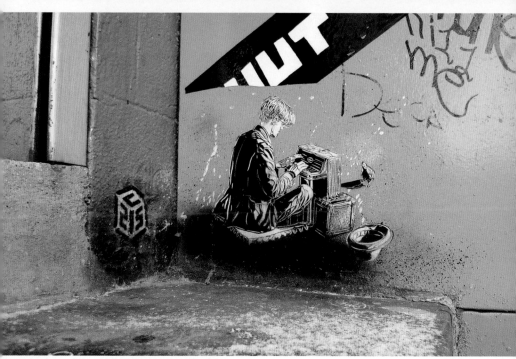

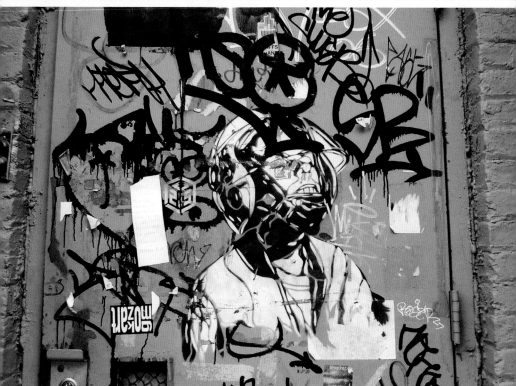

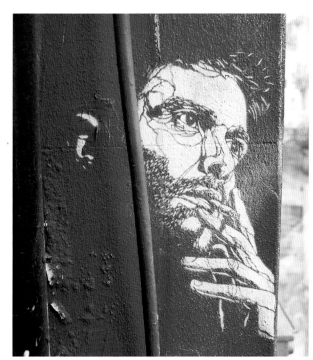

Any tips for those interested in developing their stencils?

The best tip I could give is: never follow any advice, because your process should be directed by the precise necessity of your art. If you adopt someone's process, you also adopt his style. This just makes you a copycat. The most important thing is to stay unique and find a proper style. Reading a bit about theory of colours can help. I like to use Sabotaz cans because they dry very fast.

Take your time before going to the streets painting. Take your time for cutting and first find your own style before running for success.

How do you bring the stuff with you?

Just in my bag.

Is this a political statement for you as well?

I think so. Everything is getting gentrified in Europe and America. Western people unfortunately think that graffiti undervalues real estate. Banksy is bringing a revolution because he officially adds value to a building when painting on it. I love this idea, that we add value. I think street art is one of the last opportunities for self-expression in a society that loves controlling people's minds and depriving them of real freedom. I prefer reading tags and throw-ups walking in the streets to watching TV programs on my sofa. And I prefer to paint during the day because I have nothing to hide and don't feel guilty at all.

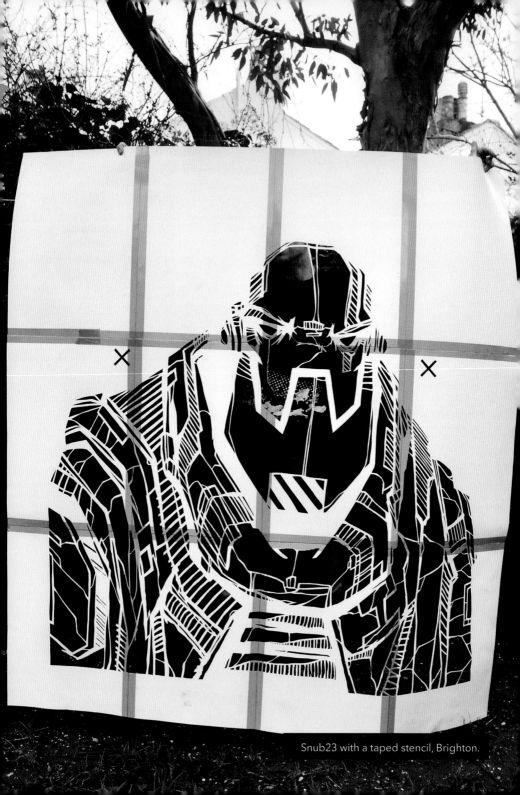

Snub23 with a taped stencil, Brighton.

SNUB23:

I just want to leave my mark

Snub23 lives in Brighton and is a member of Grafik Warfare Crew. He's a dedicated multi-artist who has been spreading his stickers, posters, stencils and paintings for ten years. One of his most appreciated images is the characteristic robot face. Here, Snub23 offers some tips to those who are going to start working with stencils.

Why do you paint in the streets?

It's all about freedom. The streets belong to us, you and me. We have a right to decorate them the way we like. Snub was born from frustration in the late 1980s.

This is more than a hobby for me. I want to leave my mark before I'm not here anymore.

How long have you been working with stencils?

Think I saw someone using them at a squat party and was instantly impressed with the detail and speed at which they got up. Working in the graphics industry, it's easy to see how effective they can be. I can virtually replicate sketches and vector images onto any surface and at any scale.

Where do you get your inspiration from?

Music, books and life spark the imagination. When I read a book I imagine the scenes and characters my own way. It´s the same with music. Soundscapes and heavy bass lines can conjure up all sorts of visual ideas. Each emotion has different colours and angles. Life is the biggest inspiration.

What's the strength of the stencil?

The advantages the stencils have are also the disadvantages. Repetition is great if you want it. But it can also become just another copy. I try not to get stuck using the same stencil over and over again. I can draw a little picture, scale it up and cut it out. Then I have a massive version to apply to a wall. This is very effective, but also a nightmare to transport and apply.

How do you come up with the motifs?

The Snub logo is one of the main motifs I use. I sketch every day, take plenty of photographs, watch TV, read magazines. It's all visual food. I hate the idea of just finding an image and making it a stencil, there's no input from you that way.

Where do you prefer to paint your stencils?

Location is really important. I actually prefer remote and eroded buildings and walls. Or broken and forgotten places in the city, it may not get the exposure that other artists get but it usually lasts much longer. A dirty rough wall is a background waiting to be used.

What kind of material do you use for the stencil?

This varies per piece and how many times I´m going to use it. Size and details also dictates the material. If I'm doing a background wallpaper pattern it will be thick card because it will stay stiff and soak up the paint to stop dripping. But for fine details on a screen fabric I'll use very thin acetate film. You also need to find out how to transport large stencils: rolled, folded or in sections. Cutting material also varies. I mostly use a "Swann Morton" scalpel with a 10a blade. Stanley blade for thicker materials.

 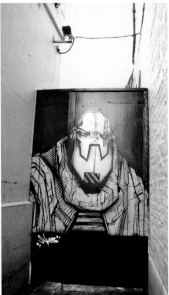 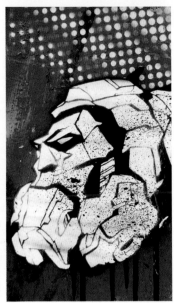

How do you prepare a stencil from scratch?

Choosing the image or designing it is the main part of the process. I think people jump from finding the image to cutting too quickly. To keep it simple: sketch or source images, scan, trace in vectors, layout the design, scale, print or project, apply to the stencil material, cut and spray. I use spray glue in the stencil preparation stages and sometimes when applying the stencil to a wall before spraying. If you research about screen printing techniques, most of it can be applied to stencilling.

Any advice to beginners wanting to make their first stencil?

Start simple, maybe just an A4 to begin with. Always keep your spare hand in front off the blade so if you slip you don't cut your hand. It hurts.

Anything else you want to add?

Instruction books are good, but no book is better than your sketch book.

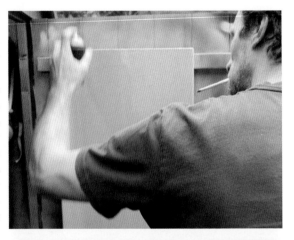

C215: instagram.com/christianguemy
Grafik Warfare: flickr.com/groups/grafikwarfare/pool
SNUB23: snub23.com
Stencil Graffiti, Tristan Manco, Thames and Hudson
Stencil Graffiti Capital: Melbourne, Jake Smallman and Carl Nyman, Mark Batty Publisher
Stencil Pirates, Josh MacPhee, Soft Skull Press

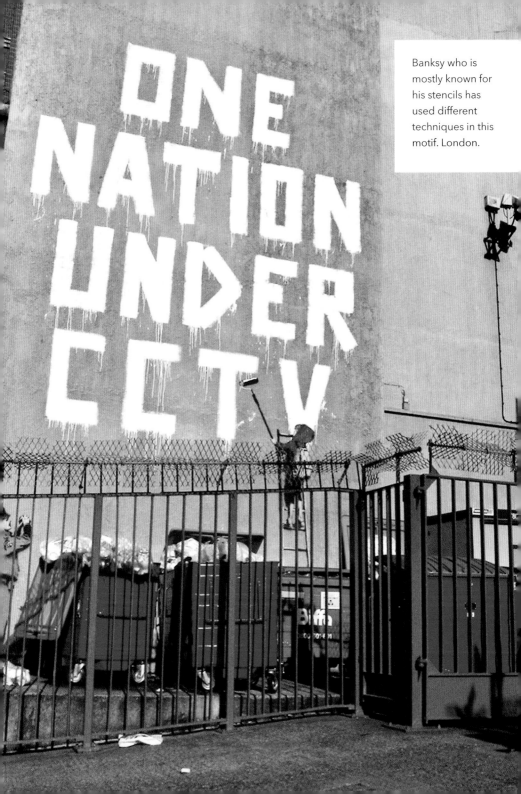

ONE NATION UNDER CCTV

Banksy who is mostly known for his stencils has used different techniques in this motif. London.

SCREEN PRINTING

Screen printing is often thought to be hard, but actually it's a fairly simple method. It's reminiscent of spray paint stencils.

One advantage is that you can produce several prints in a short time. Its advantages also include its ability to be used on the most varied materials, both soft and hard, for instance ceramics, cloth, paper, vinyl, wood, glass and metal.

Screen printing is counted among the world's first printing methods and has many names: serigraphy, through print, fabric print and silkscreen. It has been popular in artistic circles since the 1950s.

In street art, screen printing is mostly used for posters and stickers, but it's also an effective way to print T-shirts. A screen print demands a lot of preparation, so it's rarely produced directly on the street.

Caper prepares screen print, Stockholm.

CAPER:

Screen printing in eight steps

Caper are a few friends from Stockholm who have been screen printing posters and stickers in their own studio since 2003. Here, they tell us about the basics of the craft and how they work with more advanced prints.

If you are a beginner, you will need a few things you might not have at home. So go through the checklist on the next page before starting.

The most important thing is to have a working-table and the ability to rinse the frames with water, and a place where the frames can be dried and kept.

STEP 1: CREATE AN ORIGINAL

You make the image as a positive image, that is to say the black parts will be where the print colours will go. Start with one colour and a simple image. The more colours there are, the more complicated it gets. Often, images with strong contrasts work best. You can create originals in different ways:

- Using a photocopier
- Directly on film or paper using raster letters, chalk or covering marker pens.
- On a computer.

TWO WAYS OF CREATING AN ORIGINAL ON A COMPUTER:

A. Vector graphics in Illustrator.

Originals in Illustrator should be done using the tracking function. That way, you avoid problems with fonts looking different, and you can magnify them as much as you like without losing quality. Save the original as an Eps or Pdf.

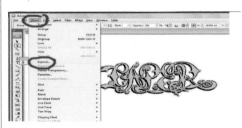

Select the image, go to "Object – Expand" and check "Expand fill and stroke". Make sure no objects are locked.

Select all, go to "Pathfinder" and choose "Divide". Select one of the colours and choose "Select – Same – Fill color". Go to "Pathfinder – Merge". Now all the lines are converted to tracks. Repeat this process for every colour.

Choose the image size. Draw register marks about 5 mm wide and 0.3 mm Stroke thickness. Copy the layer in as many colours as the print is going to be in. Name them according to colour. I name them black and grey.

In order to screen print an image it has to be rasterized.
Above the original picture and the rasterized version.

Choose the Black layer, select the other colours and make them white so that only the Black layer is visible. Make sure it's 100% black. Then go into the Grey layer, select the Black layer and remove it. Select the Grey layer and make it black. You can also expand the grey layer a bit by adding a thin black contour of 0.5 mm. If the grey field is a little bigger, it won't be as fiddly to fit in print.

Expanding or shrinking underlying colours is useful in screen printing. In this illustration, the grey colour is printed first, then black, which is a covering colour. That way, it doesn't matter if the grey gets under the black.

When the colours are separated into two layers, they can be printed. If the register marks fit, the print should be correct.

CHECKLIST:
- THINGS YOU WILL NEED

- A working-table.
- A shower with a powerful jet, or a high-pressure hose.
- A screen fabric with the right mesh for the print material.
- A rubber scraper of the right size to press the ink through the fabric.
- Emulsion.
- The correct ink for the fabric and printing material.
- A 500 watt lamp or strong halogen lamp.
- A vacuum table or a glass sheet the same size as the frame to press the original to the fabric.
- A printer or photocopier and overhead paper.
- A light-proof box to keep and dry the frames in.
- Tape.

B. *Rasterized originals in Photoshop*

Rasters are often used in screen printing, that is to say a number of small dots that form a picture together. That's good for using photographs as illustrations, for instance.

Open the image and make sure it's a good resolution, at least 300 DPI and 100% in the printing size. To convert the image to a bitmap, you first need to convert it to greyscale in "Image – Mode – Greyscale". Once the picture is in greyscale, everything that isn't 100% black or white will be rasterized when you print. The colour often expands when you print it on paper, so the image is darker in print than onscreen. Uncoated paper absorbs more ink than coated paper does.

To compensate for this, go into "Image – Adjustments – Levels" or Curves and lighten the picture up. In Levels, adjust the slider for black just above highest peak. This makes anything dark in the image go 100% black. Afterwards, lighten the whole image with the middle slider. To rasterize the image, go into "Image – Mode – Bitmap".

In Output, choose the resolution. The higher the resolution, the finer the raster dots. 700-1200 DPI are recommended.

Go to "Method – Halftone screen". Here are several alternatives for printing polychrome rasters. Frequency determines the density of the rasters. The higher it is, the more detail there is. For fine details, the value should be between 45 and 55. Another important box is Angle, which determines the angle of rasterizing. This isn't that important in monochrome print, it's used to avoid moiré patterns in polychrome print. A value of some 25° will do. In Shape, choose Round, a good screen printing raster. Try other rasters to see the difference.

Once you're satisfied with the image, you usually print it or copy it onto OH film. Remember that printers require different types of OH film. You can also use ordinary paper, but burning will take longer.

For burning, see step 4.

Check that the black areas are completely covering by holding the original up against a lamp. You can retouch the original with a good overhead pen afterwards.

If you want to make a larger image, print it out in several parts and connect them with transparent tape. Remember to overlap the prints. This is trickier with ordinary paper, since it often scrunches up. And paper originals can't be overlapped.

Always print the finished original in black. It can be screen printed in any colour. Every colour to be printed needs its own original. (When you work with polychrome rasterized prints, you usually use an elliptical raster.)

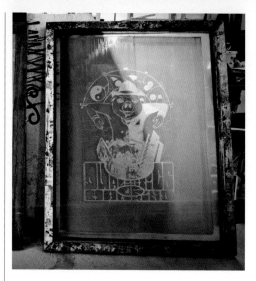

STEP 2: FRAMING

You can buy frames with screen fabric in art supply stores. They come in wood and aluminium. Aluminium lasts longer, but is more expensive and you can't stretch the fabric on it yourself, but it's worth it if you're going to print a lot. Wood frames are more fragile and can warp. Why not check with your local print shop if they can sell or donate some old frames?

The fabric should be stretched across the frame. That way, it separates easier from the print surface. A well-stretched fabric is especially important when printing with rasters.

Screen fabrics come in different meshes. The tightness is given in the number of threads per inch. For paper, a tight fabric is good. This offers the possibility to create details. A tight fabric also makes the print finer and less ink is needed.

- For textile printing, a coarse fabric of 47-77 mesh is recommended since the fabric absorbs a lot of ink. The coarser the fabric, the coarser the detail.
- For paper, vinyl glass and cloth raster prints, a fabric of 90-140 mesh, which gives fine detail, should be used.
- If you want to work both with textile and paper, use an all-round 90 mesh fabric. You use a lot of ink when printing on paper and vinyl.

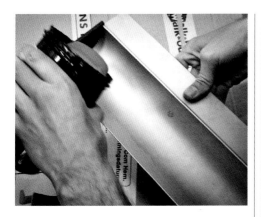

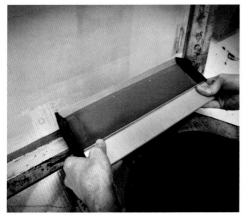

STEP 3: PREPARING THE FRAME WITH PHO-TO EMULSION

Time to make layers. Clean the frame and cover it with emulsion, which you can find in art supply stores. The emulsion burns the image to the fabric. It's photosensitive and is best kept in a black bag in the refrigerator.

Layering is a step that requires a lot of care. Cover both sides of the fabric in emulsion. Cover on the inside, outside and then on the inside again. You can scrape off excess emulsion on either side. Always keep the frame vertical during this step. You can use an emulsion roller sleeve which will distribute it evenly.

Allow the frame to dry in the dark. A fan will quicken this up. The fabric must be completely dry before it's exposed.

STEP 4: BURNING, EXPOSING THE FRAME TO LIGHT

Tape your reversed original to the outside of the screen frame so that it's the right way round on the inside. The original should be flat and still during the illumination period. You can place the frame on a foam mattress covered with black cloth, which should be a little smaller than the inside of the frame but higher than the edges so the fabric rests on the mattress. Place a sheet of glass over the original and the frame to create a vacuum between the original and the fabric.

Expose the frame to light. Strong halogen lights are the most commonly used, but a few 500 watt lamps will also work. Attach the lamp thirty to forty centimetres above the frame. Make sure it's centred above the frame and secure. Fifteen minutes of illumination is a good time for a 500 watt lamp on transparent film, but try a few different times and distances first. If you're using paper, an hour should do. The only thing that may occur when exposing too long is that details may vanish, but that's better than having the emulsion loosen when you rinse the print afterwards.

Turn off the light, remove the glass and original. Now you can see the image in a lighter tone than the rest of the fabric.

STEP 5: CLEANING OFF THE PHOTO EMULSION

Wash the frame in cold water. Rinse both sides of the frame and give the inside a good rinse. Let the frame dry.

TO REMEMBER FOR TEXTILE PRINTING

Use an ink made for textile printing. They often contain a solution that requires them to be fixed with heat so that the print may withstand washing. Nowadays, there are several environmentally friendly inks to choose from. Other types of ink can secrete carcinogens.

There are self-fixating inks that don't require heat treatment afterwards. There are even effect and burn inks, the latter gives the print a transparent effect.

When printing on light cloth, you don't always need covering ink. It's a must on dark cloth.

Use a soft rubber scraper for textile printing.

Raster images printed on cloth result in darker images since the ink bleeds into the cloth a bit. To compensate, you can lighten the rasterized positive.

You can dry the prints in a normal oven. Put them in at 170° C for a few minutes. A heat gun also works, but it's easy to burn the cloth.

STEP 6: PRINTING

Check that the emulsion is tight using a lamp. You can fill in any cracks with more emulsion or tape. Tape the inside edges of the frame so that the tape covers the emulsion a bit. This will stop the edges from leaking. When you choose ink, think of the environment and what you're printing on. Some materials require special types of ink. Ask someone with experience.

There are different sorts of paper ink, but when printing on thin paper, use alcohol-based ink, otherwise it will crease. For example vinyl paint, which mostly is alcohol-based and smells bad. It's a bit more expensive, but can be used both on paper and other materials.

If you are working with many colours and really good registers, we recommend a printing table with a vacuum system to keep the paper secure.

There are several ways to get a good register. The first colour acts as a basic template and has to be right. Then decide which corner of the paper or vinyl will be the lead. This is very important to get the fit right. You can mark this corner with a cross. Place one of the originals on printing paper. Tape the paper to the table or cover the rest of the vacuum table so that the suction is concentrated to your print surface.

Printing method A

This is a simple and playful way of seeing where on the printing table the print will appear, for instance if you wish to print the same image on different materials. You can also keep several images on the same frame, but remember to put tape over the images that are not to be printed.

Attach the frame to the printing table. Tape transparent film (the transparency) to the table. It should be able to withstand cleaning and be larger than the frame. The printing paper should fit under the film. Print the image onto the transparency.

Lift the frame and fit the paper with the original under the transparent film. Fold the transparency away. Tape the paper, place your register marks around the marked corner so that they lie tightly against the paper and evenly spaced along it.

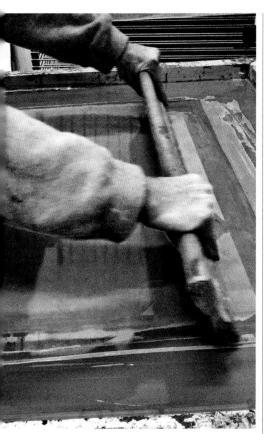

Now the print will land where you want it.

Printing method A, second colour

Start as with the first colour, print on the transparency. Place one of the prints with register marks under the transparency and fit in the print, fold away the transparency and secure the print with tape.

It's important to place the register marks around the marked corner, preferably in the same place along the edge of the paper. Then just go ahead and print. If you notice that the print doesn't sit right, go through them to check if there are any similarities in the misfits. Then move one of the marks a little so the print sits right.

Printing method B

This is the professional method, for a really good fit in which the ink fits to the millimetre and requires a good printing table, preferably with vacuum.

Place the register marks on the table at 90° angles.

Place the original with the marked corner along the register marks and tape it. Make sure the paper is flush against all the register marks. Place the frame according to the original's register marks. (It's important to place the paper exactly the same way, so you need to find a natural way of moving the paper against the register marks so that it's consistent during the whole printing process.)

Printing method B, second colour

Don't move the register marks, but place one of the papers with register marks against the same receiving edge as the colour and tape it.

It's important that the second frame is burned or that the second colour is placed on the frame in such a way that you can use the same application marks on the screen table. Then simply adjust the frame to the print's register marks. By fine-tuning you can adjust the print when it doesn't fit. If printing more colours, just follow the same procedure.

RUBBER SCRAPERS

Rubber scrapers are available in several sizes. Get one that's big enough for the frame, at least two centimetres wider than the print. The hardness of the scraper is given in shores, in which a high number is hard and a low number is soft. The medium is 75 shores.

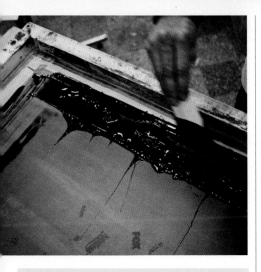

REMEMBER BEFORE PRINTING

Once you have adjusted the print, build up a little slack which means that the back of the frame should be a little higher than the front. This is to create a small distance between the fabric and the printing surface. When you pull the rubber scraper over the fabric, it has to lie against the print surface, but as soon as you stop pressing, the fabric should lie free.

Tape something under the frame or table to create the slack. Cover the rest of the table, and the vacuum suction will concentrate on the paper. Before placing the frame against the paper or cloth, pour the ink against the side of the frame, avoiding the image itself. Then make a flood stroke with the scraper to fill all the open parts of the stencil with a thin layer of ink.

Fold the screen down and firmly make a print stroke with the rubber scraper. The angle should be about 80°. If the print gets messy, just fold the frame up and clean the underside with paper and acetone. It might be due to insufficient slack, that the paper doesn't fit well on the table or there is too much ink in the fill-in layer on the fabric.

STEP 7: DRYING

If you don't have a drying rack, you should have plenty of space to place out the prints while they dry. You can arrange this in a flat with a few tricks. Some narrow shelves or a washing-line with pegs go a long way. Remember that alcohol-based inks smell and contain solvents, so a gas mask and open windows are preferable.

STEP 8: CLEANING

Clean the frame and fabric as quickly as possible with a detergent that is adapted to the ink. If you are removing a stencil, spread emulsion remover on both sides of the fabric. Allow it to remain until the emulsion starts to run. Then rinse with a powerful jet of water, a high-pressure hose if possible.

A so-called phantom image may remain on the fabric after it has been cleaned. It's usually not visible when you print and will soon wear off. It can be removed with a detergent specifically designed for phantom prints and ink stains. Apply to both sides of the fabric. Use a face mask and gloves. The fabric should dry before you use it for a new stencil.

DP:
DIY screen printing

DP, from Stockholm, built his own screen printing press at the age of fifteen and spread his stickers across town for many years. Now he has found other forms of expression, but still wants to master the craft of screen printing from start to finish. DP points out that do-it-yourself printing doesn't always get the same result as professional printing, but that shouldn't be an obstacle to producing your own posters, stickers or T-shirts.

A FRAME OF YOUR OWN

A frame is a good investment for someone who is going to print a lot. But a home-made one is simple and cheap to make. I use a solid bit of wood, about 5x5 cm thick. I take whatever I can find and often go dumpster diving. The bits of wood are sawn into pieces which will gradually make a stable frame. Nails, glue, brackets and screws are good tools.

In order for the frame to keep its shape when it's wet, I paint on a few layers. Use an oil-based paint or something similar. You can get defective paint in paint shops. I buy the fabric in art supply stores or at eBay resellers. The latter sell cheaply per metre and freight costs are low.

The fabric should be stretched like a drum on the frame, the tighter the better. You need two people to stretch it, one to stretch and the other to fasten it. Use a tool to stretch the fabric across the frame. You can stretch it by hand, but it's hard to get a good grip and the fabric can easily tear.

I fasten the first bolt in the middle of one side, then stretch the fabric outwards towards the edges. Once the first side is stretched I do the same thing on the opposite side. Here I focus on stretching the fabric outwards. Then I continue on the other two sides.

Different materials require different types of fabric see p. 62.

Different materials require different types of fabric see p. 62.

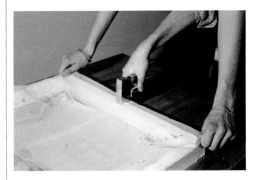

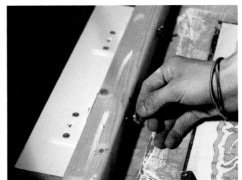

A PRINTING TABLE OF YOUR OWN

Building a printing table is pretty simple. Of course, it's a bit primitive compared to a professional table, but the principle is the same.

I attach a hinged wooden plank to the frame. I use hinges with screw holes. I start by attaching them to the plank, preferably raised a few millimetres. This reduces the risk of smearing the ink when I print on paper. Then I place one or several sides of the frame against the folded-out hinges and mark where the screw holes are going to be with a pen. I drill the holes and varnish them as much as possible inside to avoid damp.

I attach the frame to the hinges by threading flat-bottom screws through the holes and hinges. Then I screw a wing nut to each screw and tighten it. That makes them secure, but they can quickly be loosened by hand.

Place what's to be printed on the print board. Paper on top, T-shirts on the board so that a layer of material is situated between the frame and the board. To avoid the printing surface sticking to the wet material, you can attach it to the board with spray glue. When printing on paper, tape will do.

An advantage to this solution is that it's portable and can be placed on any table. If printing on textiles that are to be slipped onto the board, you might want to saw it to the same width as a T-shirt, for instance, from the start. This is especially important when printing on less elastic cloth.

USING A SPRAY STENCIL AS A SCREEN FABRIC

If you haven't got a fabric you can use a spray stencil. I print my stencil on OH film and cut it out with a knife. The half-transparent frame is placed above the stencil to see where the OH film ends. I tape a few centimetres inside the film edge so that no ink will leak or spread outside the stencil. Then I fasten the stencil with tape or spray glue on the underlay and pull the scraper over the stencil.

SPRAY STENCILS FOR PRINTING T-SHIRTS

You can print T-shirts with a spray stencil. Many work with OH film. It's thin and works well with a roller. You can also print the original directly onto the plastic. You can use vinyl with glue on one side. It sits well. Unfortunately, it's hard to use several times.

Most people attach the stencil with spray glue. Use a kind that won't leave bits on the cloth. The glue also serves as a stop to the ink. Make sure the stencil is tight against the cloth, otherwise ink may leak at the edges. Make sure the shirt is stable by taping it to the table. If you want to use several colours, put masking tape around the corners of the first stencil. This will serve as a marker to know where the other stencils are to be placed.

Don't forget to put something inside the shirt, cardboard for instance, otherwise the ink will penetrate right through.

To apply the ink, you can use a spray can, roller or brush. The roller has several advantages. It presses the paint into the cloth and there are many inks specifically made for cloth printing. Make sure the roller absorbs plenty of ink, or it can easily miss parts of the print. Spray paint lies more on the surface.

If you want really good textile inks, you have to ask in specialised stores. There are inks that are more or less transparent, inks made for printing on

black cloth, and so on.

Spray, roll or brush the ink on and let the shirt dry properly before removing the stencil. The more ink, the stronger the print, but it increases the risk of leaking. Less ink makes sharper edges, but weaker print. It's easy to end up with diffuse edges if you use spray paint or a roller even when the stencil is tightly applied. You can remedy this by rolling several thin layers.

The technique of stippling, knocking a brush against the surface, can be effective if you want a really sharp image.

Fix the print with an iron. Put a sheet in between. Be careful not to get it too hot. A good textile ink usually fixes in fifteen seconds both inside and out. The temperature will be specified on the can. Remember that some spray paints form toxic gases if you iron on them.

If you are using several colours, each layer should dry and be ironed separately.

The print can handle 40°C in the wash. Don't forget to wash the shirt inside and out.

INK

There are advantages with screen printing inks, but on paper especially, you can print using most things. Ordinary wall paint, model paint and acrylics work fine as long as they don't dry into the frame.

CLEANING

Avoid the expensive detergents sold in art supply shops. After printing, it's enough to remove the ink with water. When you're removing a burnt-in print or old dried paint, a high-pressure rinse will do fine. It may take a little while.

For printing on vinyl plastic, you often come across alcohol-based ink that doesn't wash off as easily as water-based ink. But a high-pressure rinse and a bit of soap will do it.

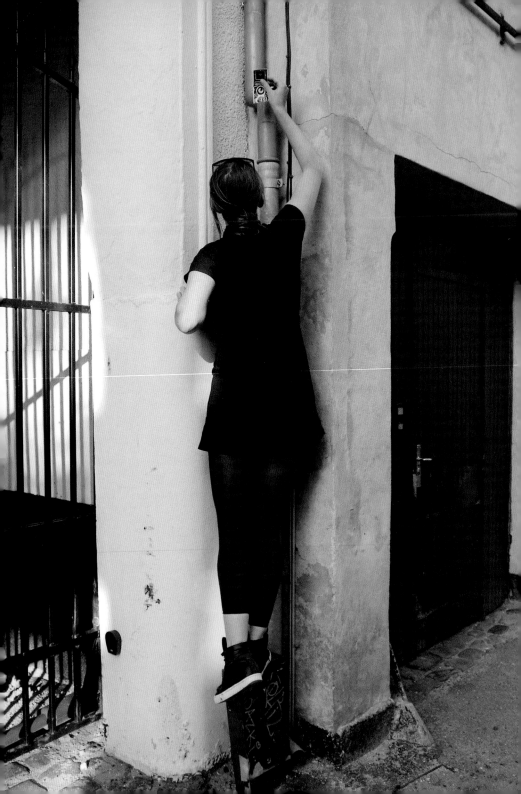

STICKERS

Stickers are like tags – the smallest in terms of format, and most widespread. If you look around, you will soon notice that they are everywhere: on lamp posts, relay stations, and street signs.

Since stickers are simple to make and easy to put up, they are popular among street artists. For many, this is also the first material they use.

There are of course those who find them a bit too simple or banal. Stickers run no risk of becoming the darlings of the established art world. They hail from a wild folk culture mix of highbrow and lowbrow, serious and jocular.

Street artists like Obey, Tower, Mildred and Tika experiment with both form and content. And through enthusiasts who run so-called sticker exchanges, the results are spread worldwide.

Hello Banana puts up a sticker in Århus.
Spread pp 72-73: Wall with stickers, New York.

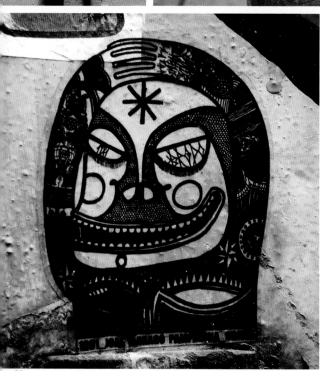

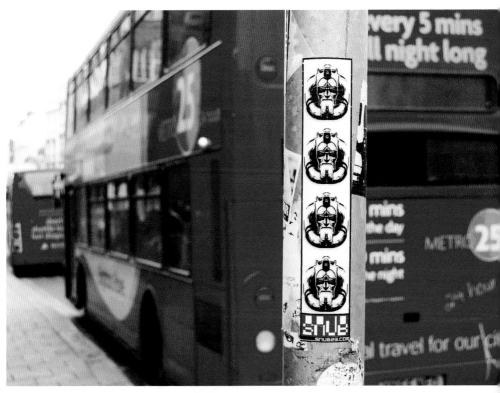

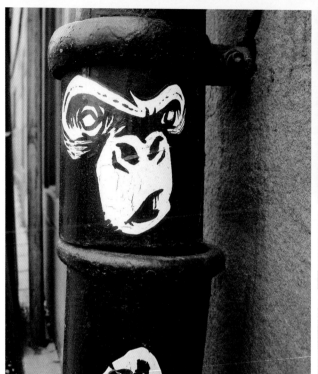

HOP LOUIE:

How to make your own stickers

The whole point of stickers is small and simple. I can basically put one up anywhere, and nobody reacts when I do. The size makes it easy to find free spots.

MOTIFS

Since stickers are often small, the motif should be clear. If they are too cluttered, they're less visible. I think it makes sense to develop simplified, pure motifs, just like companies do with their logos.

PRODUCTION

There are several different ways of making your own stickers. Sometimes I order them off the web from companies who print them for me. Quality is uneven, so I try my way ahead. It's important to check the delivery time before ordering.

Otherwise I get some paper with adhesive on one side, preferably vinyl paper, and create the motif using a spray stencil, screen print, stamp or photocopier.

Many draw on pre-printed stickers. This has become a sport in street art. The most well-known is "Hello my name is", which is used at conventions, and labels that you can find free at the post office. Old jam jar labels or floppy disc labels – the only limit is your imagination.

You can use the same technique as for posters when making stickers in the format and on the paper you like. Then you use paperhanging paste to put them up. Why not "laminate" them with transparent packing tape?

MATERIALS

When I make my own stickers, the choice of material depends on where and when I want to put them up, and how long they should remain. Vinyl is weatherproof, but unfortunately quite expensive. One tip is to look for screen printing shops that have just gone out of business. You can find a lot there. Paper is cheap, but fades quickly and doesn't stand water well. The advantage is that it's difficult to remove.

TRANSPORTATION

I always carry a bunch of stickers in my pocket. Of course, they can get scrunched up and I can't always fit in as many as I need. Some use coats with large pockets, others have a specially-adapted pocket for their stickers. I've heard about people making books with pages of the same material as the stickers adhere to before use. They can insert the stickers and get the right one out quickly. Moreover, a book doesn't attract attention.

SPOTS

Stickers suit most places, but I avoid putting them on privately-owned objects. My philosophy is that a sticker placed somewhere people don't have anything in particular to look at gives them something more fun to look at than grey concrete, for instance.

Smooth and clean surfaces, with as few cavities as possible, are good, for instance sheet metal, glass, and plastic. The sticker will loosen pretty quickly on concrete and wood, and on dirty surfaces too. In spots where stickers stay a long time, cool "Halls of Fame" are formed. A signpost or a wall are successively filled in, becoming a spontaneous exhibition.

PUTTING THEM UP

A good tip is to slightly fold the stickers in the middle. That makes them easier to "peel" and put up. Stickers are like small, self-adhesive posters. Just like with posters, I squeeze out all the air bubbles so the sticker will be as flat as possible.

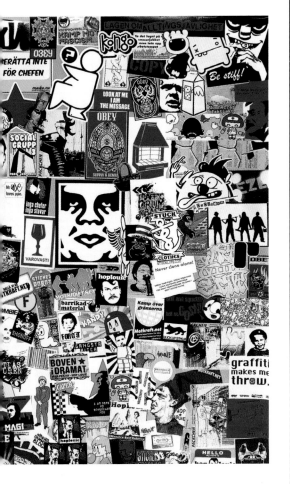

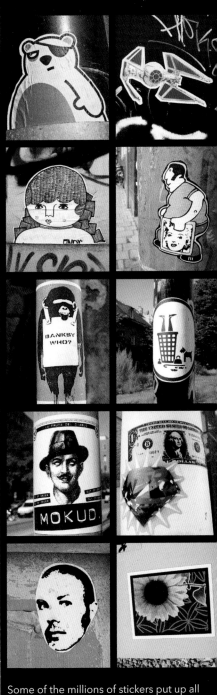

Some of the millions of stickers put up all around the world each year.

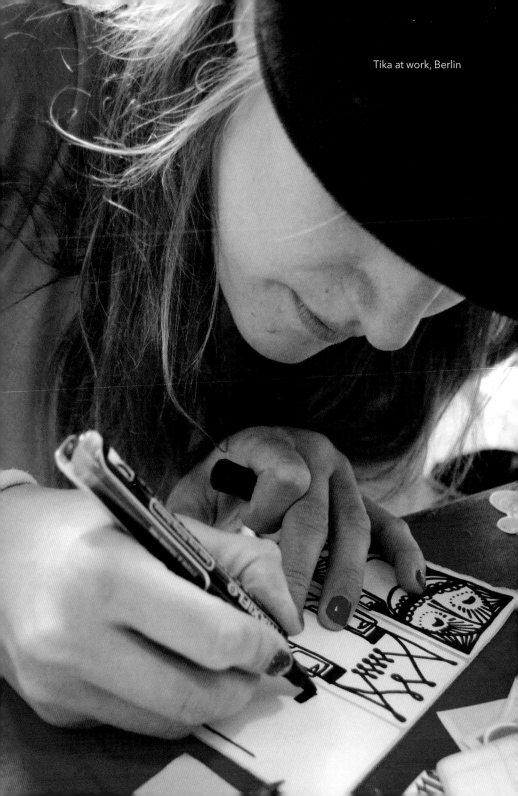
Tika at work, Berlin

TIKA:

Fighting the grey and monotony

Tika lives in Berlin and works with a variety of methods: stickers, paste ups and freehand. Her handmade stickers, which often involve the character of a fat-nosed Aztec, are full of variation and details and engenders their own imaginative world.

Why stickers?

Stickers are easy and quick to put up a lot of. I like to walk around in the city and have a stack with me. My work is about expressing thoughts, creating reactions and fighting the grey and monotony. People that are reclaiming nature, nature reclaiming public space, the stiffness of life in the tight grid of society and the enigmatic reputation death often gives to a passed away person.

How do you create your stickers?

I flip through my sketchbook and take pictures of what I see as a sticker. I work on it in Photoshop, print a film, prepare the silkscreens, and either print on a friends half automatic monster printer or all day long by hand, sheet by sheet. Usually two colours. Then the damn cutting out everything by hand process. Before I used to put them up single. Now I prefer to make sticker collages with coloured sticker foils combined with image-stickers I found somewhere or even Letraset stickers.

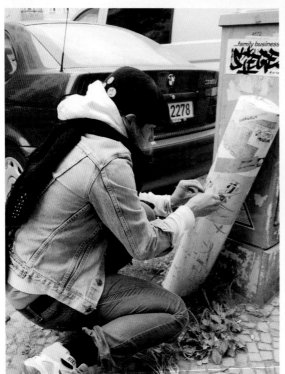

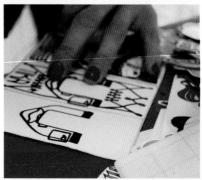

What's a really good place for a sticker?

When I put single ones up, it's best to have them at eye level; places where people who are not street art affiliated will see them. The collages I put in surroundings where they make a nice picture. Sticking is not something I prepare much. I just have them with me.

What was it that attracted you to working in the streets?

That no one knows who you are in person. That you can have your own secret. That you reclaim space. That it has to be quick. When I go stickering or tagging, I just take stickers or markers and see where it brings me.

Tika: womenstreetartists.com/tika-1

Tika puts up a sticker in Berlin.

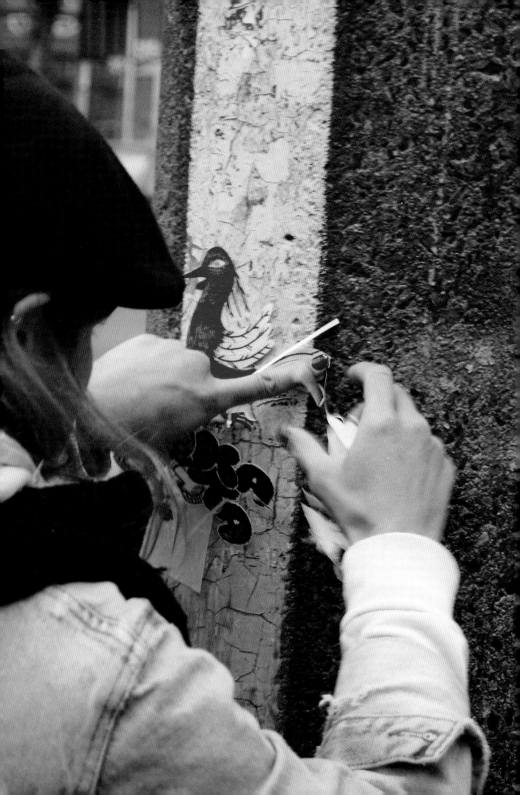

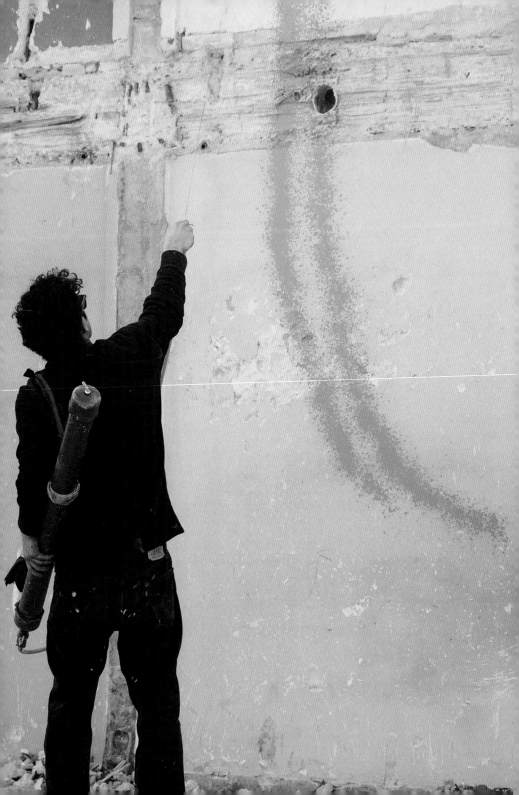

FREEHAND

The means of expression are rife for people who work in freehand: scrawls, drawing, graffiti, murals or collective painting. Some spend much time with their sketchbooks, others improvise.

The works can take anything from a few seconds to several days to execute. The artists have in common that they work in situ and directly on the surface: the wall or asphalt. Their tools, whether they are bought or homemade, are too many to mention comprehensively, but some are more common than others.

Fumakaka demonstrates their Sembrador de Terror in Lima.

Spread pp 86-87: Painting by Blu and JR in Berlin.

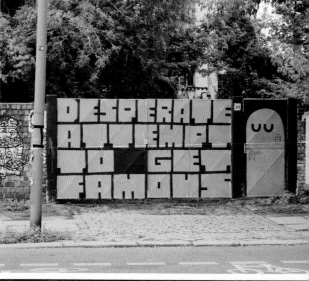

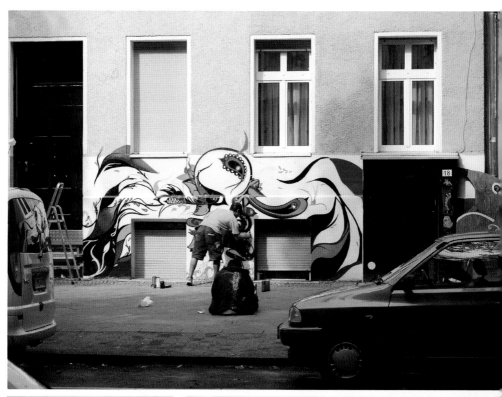

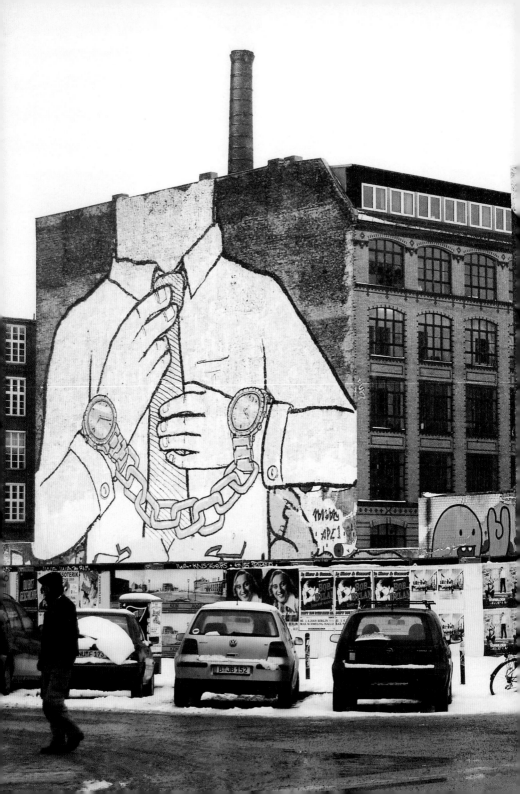

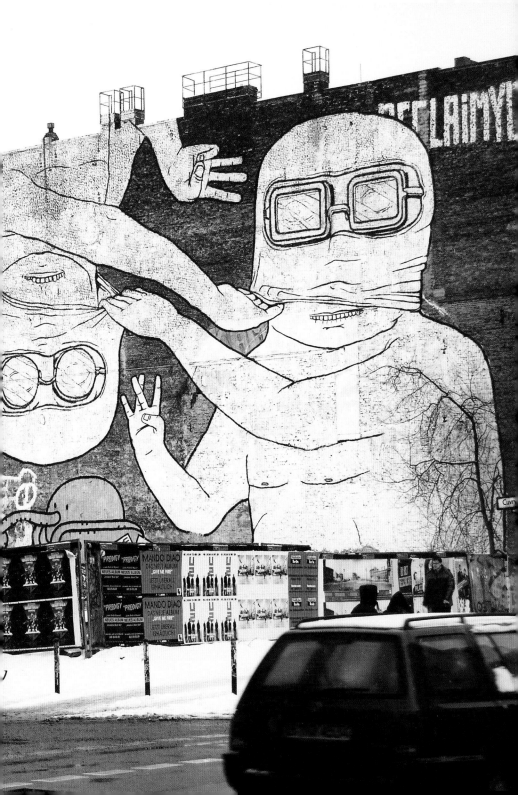

SPRAY CAN

When the spray can was invented in the 1920s, it was not intended for art, but since the 60s artists have been using it diligently, not least graffiti writers, and they can now be found in countless varieties.

The spray can is simple to use, but practice is required to master control. Since the paint begins to run if the can is held still, you need quick but even, gentle strokes. Several layers of paint will produce better results than one thick one.

Different types of nozzle – thin, normal and fat – regulate the breadth of the spray. Applying pressure to the centre of the nozzle will produce a powerful spray, while pressure at the front "spits" out the paint, and at the back, a thinner spray is obtained. The results also depend on the angle that the can is held at. For an extra thin spray, you hold the can upside down. Since the paint is covering, it's easy to alter things that didn't start out so well. Spray paint is suitable for painting large themes. It sticks to most surfaces and is permanent. The drawbacks are that it's smelly, toxic and messy. And provocative.

MARKER PEN

Marker pens are easy to use and suitable for those who want to work quickly and spontaneously. The ink dries quickly. However, it doesn't work well on coarse materials like wood, stone or concrete. Even though a large marker pen industry exists today, many experiment at home to obtain more durable, wider, fatter or runny ink. One of the most noteworthy street artists to use marker pens is of course Jean-Michel Basquiat.

BRUSH

Brushes offer great opportunities for variety for the street artists. Generally speaking, it's considered to create good-looking, well-structured lines. It gets messy easily, and has to be dipped often. There are as many techniques as there are practitioners, from Dan Witz's detailed and realistic works to the murals of Los Angeles and Latin America.

ROLLER

A roller allows you to paint large surfaces quickly. It creates visible art, like Akim's and Just's pieces in Berlin, or Kegr's and Tomcat's in Copenhagen. The roller is suitable for straight lines, and a long handle makes it possible to paint high up, or down on walls from a roof. It's also effective for creating new, clean surfaces to work on, which was common in Melbourne in the early 2000s, when the spray stencil invaded the city. The roller is bulky, messy and requires a lot of paint.

CHALK AND CHARCOAL

Chalk and charcoal are used by many artists who have moved onto the street. Keith Haring for example. The material offers an attractive structure, but the theme quickly disappears, almost immediately if it rains. Chalk and charcoal are often used by children.

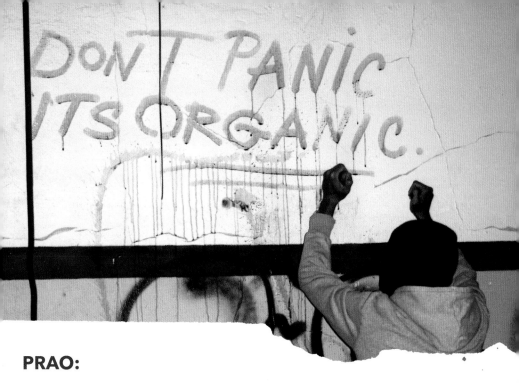

PRAO:

How to make a marker

Swedish artist Prao often works with political statements. Among his most noted works are larders for the homeless, placed around Stockholm. Here, he shows us how to make our own environmental pen. It works best on smooth materials.

HOME-MADE SQUEEZER

This is a recipe for those who want to work without toxins. I have produced four colours: blueberry, beetroot, soot and ash. Here is the recipe for blueberry.

You'll need:

1 litre of blueberries
1 squeeze bottle with a sport cap
1 stump of strong nylon string
1 section of terrycloth towel
1 coffee filter

THE INK

Cook the blueberries with a glass of water on low heat until they have boiled to pieces. Then sieve them through the coffee filter. The result is an entirely nontoxic ink with high pigment content.

THE PEN

Attach the terrycloth to the sport cap with the nylon string. Tie it firmly, preferably burning the knot so that it's really tight. You can secure the cap with a rubber band so that it won't close by accident when you use it. Remember, it can leak during transport.

Fill the bottle with ink. You'll need a lot, especially if you press hard to make it run properly, so you can use a big bottle, though this is harder to grip and control.

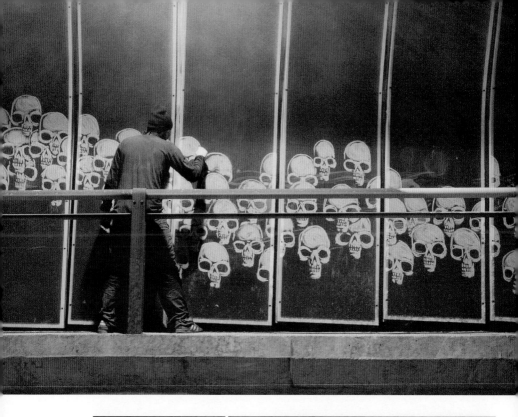

ALEXANDRE ÓRION:

Don't trust cookbooks – experiment

Órion was born in south São Paulo and started practising street art at the age of 14. He often integrates his art with photography. In 2008, when he removed dirt form a traffic tunnel - reversed graffiti - he gained attention worldwide.

How did you get the idea of reversed graffiti?

The municipality built a car tunnel which was yellow when it was inaugurated. In a short time, its walls were completely covered by soot. It bothered me and I decided to turn the tunnel into a catacomb inspired by archaeological sites and the Mexican wall of skulls. One early morning, I went to the tunnel and found a way to draw. All the skulls were done by hand and I spent 17 nights working on them, 6 hours each time. The result was more than 3 500 skulls on 300 meters. At that point the municipality turned up to clean the tunnel.

What materials do you use?

Powerwash, brushes, rags or sponges to do freehand drawing. It's possible to use stencils. I was able to clean the tunnel walls without needing any equipment, just damp cloths for "freehand drawing".

What do you look for in a spot?

A good intervention is one that dialogs with a place and resignifies it. Works done at night have an air of illegality. Generally, the more explicit they are, the less illegal they

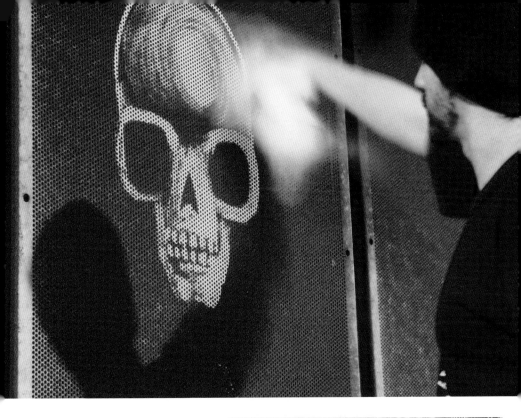

will seem. In tunnels I always work at night when there is less traffic, less pollution and less noise.

What should a beginner think of?

Reverse graffiti is a new possibility. But I wouldn't make a tag with my name by cleaning a wall. Techniques are just a path of conveying something. There is a longstanding partnership between form and content. The idea has to anticipate the technique. So don't trust cookbooks. Don't follow trends. Experiment.

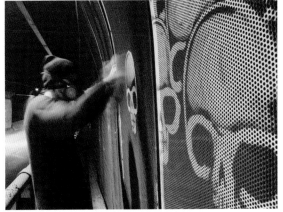

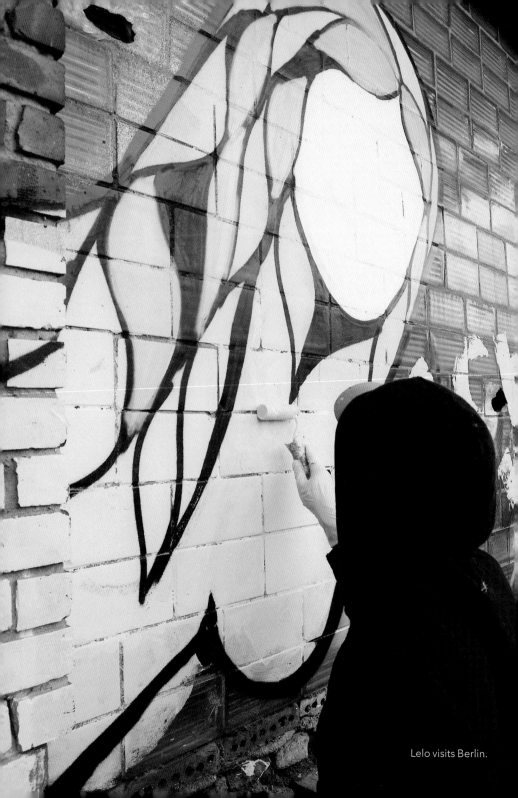

Lelo visits Berlin.

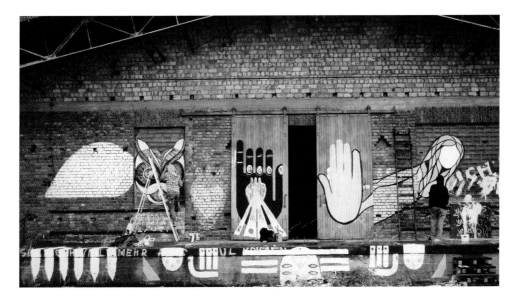

LELO:

Style is everything

Lelo, from Rio de Janeiro, likens the urban landscape to his painting canvas. He begins with the influences of his childhood - comics, video games and fantasy - and likes to work on larger pieces. The results are recognisable characters in several colours, in a Latin American tradition of mural painting covering entire walls.

Do you plan a lot before you paint?

I have my sketchbook where I create basic ideas, but they are just the point where I start my work. The spot has to say what work is needed. I'm always looking for walls that have interesting architecture and texture and I normally don't paint backgrounds. I like the spot to be the background, and my work to integrate with the place.

What kind of materials do you use?

I use all kinds of materials: spray paint, latex and acrylics, brushes, rollers, markers, stencils for creating patterns. Sometimes I paint with my fingers, like kids do.

I carry the latex separated in plastic bottles so I can mix the colours myself with pigments. Spray cans and other equipment I have in my backpack or in the plastic milk crate tied to the back of my bicycle.

What advice do you have for someone interested in painting?

Style is everything. You can master any technique, but the most important thing is to create something that's original and got your own touch. What you want to do has always to come before how you're going to do it. And never get stuck on standards and rules of how to make things, always keep on innovating.

I got the idea for this piece when I saw the door, I wanted the hand to open the door. For the fills I brush painted with latex, brushes work best on rough walls. To make fine lines with the spraycan I used a cap with an injection needle inserted.

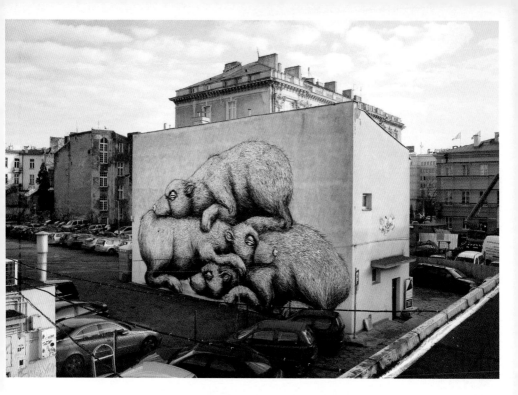

ROA:

Animals in the backyards of the city

ROA started off as a graffiti writer in Ghent, and in later years has made a name by painting realistic yet slightly unreal animals in cities the world over. Here, he talks of bears in Warsaw, his biggest work yet.

What's the joy of painting in the streets?

That you can do something in a location that offers both the location and the work another perspective. I need time to paint my animals. For that reason I like to spray on a quiet and relaxing place like a deserted factory.

How did you prepare the bear painting?

Vlep[v]net, a Polish collective, invited me to Warsaw to paint this wall and sent me a picture of it. I drew a sketch, but I really need to see the place and feel the environment before I can make the image.

Do you sketch a lot?

The most essential sketches I do in the abandoned factories in my neighbourhood. It's like a playground where I do everything I want. For the bears I drew some classical studies, because I didn't paint bears before and this scale was a challenge for me.

What kind of material and techniques do you use?

I mostly use black and white spray cans. It brings my motifs more life with contrast and shadows. When I use colours I often use red and blue which refer to the anato-

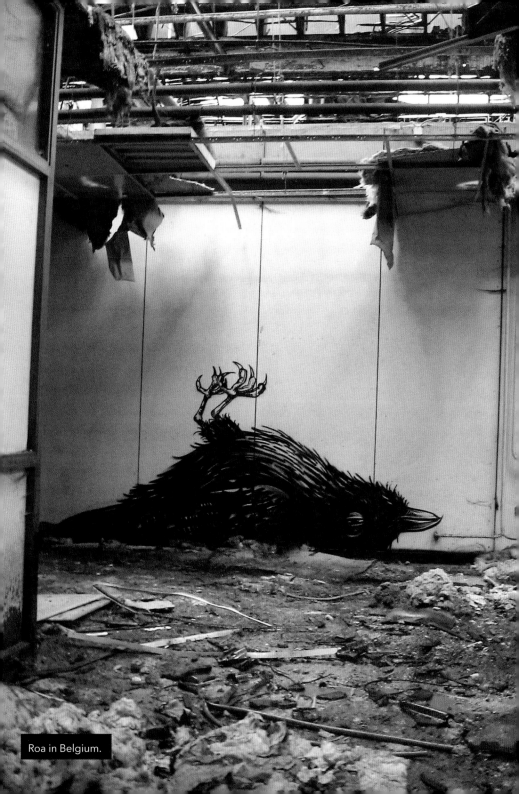

Roa in Belgium.

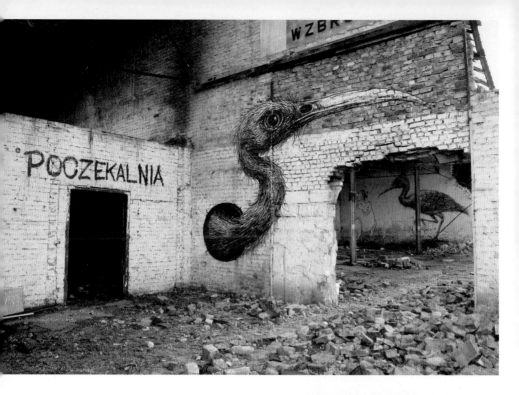

mical maps in schools. At the same time I started working in black and white I began to spray like I sketch, free and wild.

The surfaces offers colour and texture a lot of times, which becomes a part of the image. I use my own innovative pole-stock with cans. I also latex paint big surfaces to work faster and make it more plastic.

How is it to work in this format?

It's an absolute pleasure. This scale was new for me and it took a lot more time I ever thought, two whole days. It's a challenge to get the proportions right. To show oversized animals is somewhat surreal, sometimes a bit dubious too.

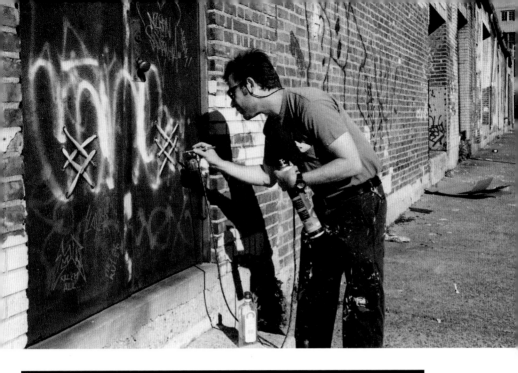

DAN WITZ:

Ignore the experts

Dan Witz is one of the true pioneers and figureheads of street art. Inspired by subway graffiti, his love of the punk aesthetic and the irrelevance of the established art world, he began painting in the 1970s. Since then, Witz has repeatedly managed to surprise, challenge and provoke New Yorkers with his skilfully executed works.

Tell us about your art.

The overriding motivation has always been to get out of the studio and make work that's free – in all the definitions of the word. As a painter I'm a student of old master techniques of simulating reality. For my street pieces I combine that craft with visual sampling and digital imaging techniques. Usually I'll paint over a photo-shopped image, using my representational skills to make it look more realistic, more three dimensional.

I use whatever's necessary. Oil, acrylic, markers, crayons, ball point pen, glitter. I really like the airbrush. I suspect it of having magic powers.

In New York City, with the rise in real estate prices and the consequent lowering of tolerance for street art, my installation strategies have had to evolve. Back in the late 1970s I could get away with standing outside and painting freehand, but with gentrification and the aggressive attitude of the police in New York City, those days are over.

With the police cracking down and graffiti becoming a felony in the 1990s, I had to get off location faster. I started using stickers

or modules that I made at home, integrating them into the wall with an airbrush. Ironically this adaptation has caused my output to be of a much higher volume and more pervasive than if I'd been left alone to just paint on a wall.

These days, the time I spend at risk on site could be less than 60 seconds. I work from my motorcycle, out of a portable studio in the saddlebags. Before anyone can figure out what's happened, I'm usually already gone.

What areas are your favourite to put your art up in?

Usually the perfect spot is a combination of factors: first, where the most people might see it, second, where it won't get immediately removed, and third, a location where the installation risk is acceptable. Location is sometimes the conceptual trigger for an idea like with the "Hoodys" (1994) and the "Ugly New Buildings" (2008). My current projects, "In Plain View" and "Dark Doings" are adaptable to almost anywhere. Every piece I do though has its origins in New York City.

What advice would you give a beginner?

I will say that I'm totally amazed at how many people are doing it these days, but being asked for my expert opinion makes me uncomfortable. It's suspiciously close to acknowledging that I've become part of the establishment that I started out rebelling against. So, ignore the experts. Rebel. The thing I'm interested in is what's coming next. Since street art is so in fashion these days, inevitably it's got to go out of fashion. I'm wondering what the backlash is going to be, which way the aesthetic pendulum is going to swing. I'm intensely curious to know what kind of future art is coming that's as challenging and paradigm shifting as street art is right now.

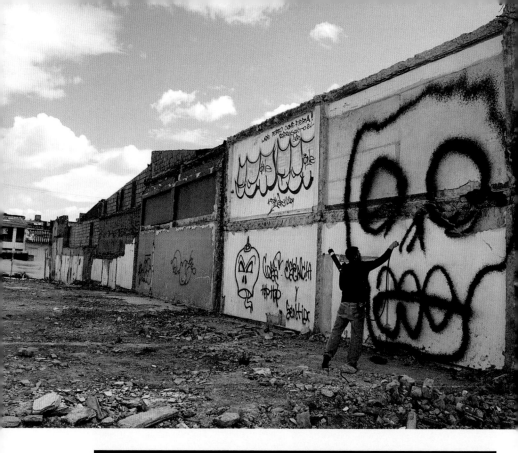

FUMAKAKA:

Painting in the streets is interaction with people

Fumakaka is an art collective from Lima. They work with everything from graffiti to large installations of junk, and constantly test and experiment with new techniques and tools. One example is the paint sprayer Sembrador de Terror.

How did you get involved in street art?

We started by painting our names on school walls and nearby parks. Later on we tried other materials, surfaces and techniques: acrylic paint, rollers, brushes, extensors and stencils. We also started sculpturing creatures to place in the streets.

We do things for the pleasure of doing it, and we do it for the kids. Painting in the street is interaction with the people that are, in a certain way, forced to see your work. And we like to break the monotony of the city.

What's the Sembrador de Terror?

We started out doing special effects like firing blood with compressed air systems in a theatre play. Then we put that knowledge on spud guns. We also fired potatoes with paint; colour potatoes bullets. It didn´t work, we couldn't control it properly. But there were plenty of ideas of how the me-

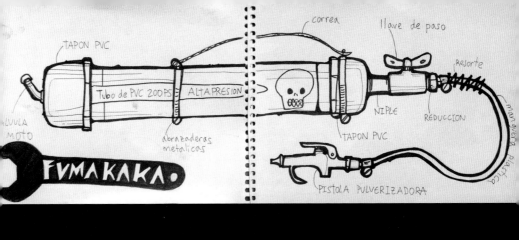

Labels on diagram:
TAPON PVC
correa
llave de paso
Resorte
Tubo de PVC 200 PSI ALTAPRESION
ALVULA MOTO
abrazaderas metalicas
NIPLE
REDUCCION
maniobra plastica
TAPON PVC
FUMAKAKA.
PISTOLA PULVERIZADORA

chanism could work out better and finally the Sembrador de Terror was born.

Tell us more about working in the streets of Lima?

In Lima where crime is very high, police are more occupied on other cases. But that doesn't mean you won't get in trouble. When using the fast Sembrador most people don't have time to react. And then we're gone.

Some ides for a beginner?

Always try new materials, mix them to get new results. Never give up, practice makes you a master.

HOW TO FILL A POSCA PEN

A marker refilld with alcohol based ink writes with ease on smooth materials like paper, steel and glass.

Empty an unused Posca pen. It should be without a filter, with a ball in the shaft and water-based ink. Screw off the top, which is threaded clockwise, remove the pump mechanism and fill the shaft with alcohol-based printer's ink. Put the pump back, screw it shut and add a few lengths of tape around the join to prevent the pen from leaking. Pump a few times until the ink flows through the filter.

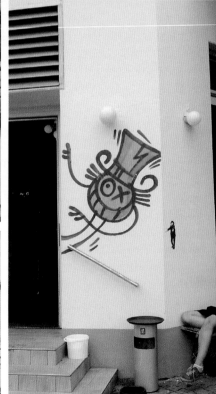

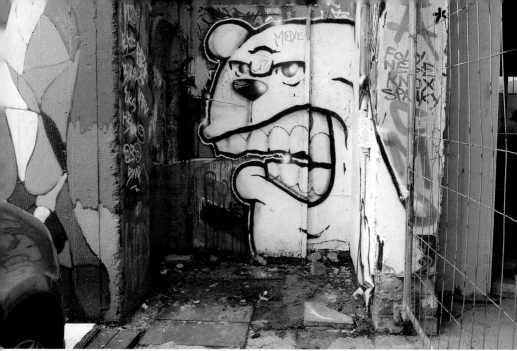

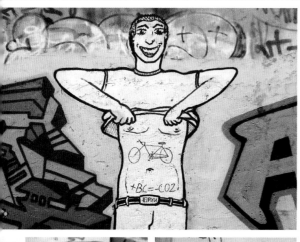

Fumakaka: ekosystem.org/tag/fumakaka
Lelo: instagram.com/lelo021
Alexandre Órion: alexandreorion.com
Prao: rubenwatte.com
Roa: facebook.com/ROAStreetArt/
Dan Witz: danwitz.com

INSTALLATIONS

Small hand-painted plastic figurines, tape statues, knitted objects and a gallery outside a subway station – installations are a branch run wild in street art. Unlike traditional street art and graffiti, they are often three-dimensional and move the focus from the city as a canvas to the city as an environment.

The street installation is designed for a special spot and can consist of several materials and techniques. It often plays on the feeling of absurdity, but it's up to the passers-by – if they even notice it – to create meaning for it.

The installation is becoming increasingly usual in street art since it gives the artist the opportunity to develop by testing new techniques and materials. Lately, many have used modern technology to work with light and sound – light graffiti is the latest addition to the genre.

Mark Jenkins exhibits in Washington.

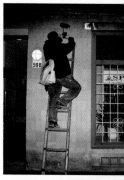

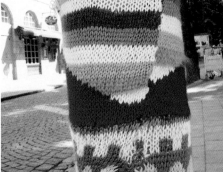

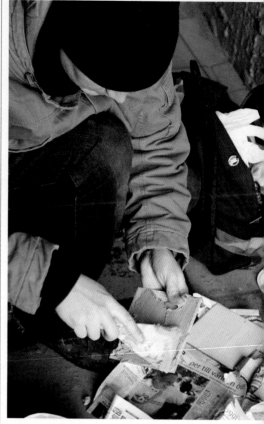

HOP LOUIE:

How tiles work

THEME

I like to make intricate spray stencils on tiles. Others use paper and varnish, paint directly onto the material or make tile mosaics.

The tile sits where it sits, but the paint loosens, sometimes after just a few days. That's why I make a foundation with wall paint before spraying the image on.

I put my tiles on a table, in the order I want them to sit on the wall. When the spray paint has dried, I wrap every tile in newspaper to avoid scratches.

Then I pack every image together and pull some masking tape around them so they hang together. A piece often consists of four to six tiles.

MATERIALS

The cheapest tiles available at building stores work fine. I've tried two types of cement, a cheap powder sort that unfortunately dries too quickly and a ready-mixed sort that is smoother and dries slower. If you look in the right places, you can find free cement. Of course, you can also use strong glue.

TRANSPORTATION

Both tiles and cement are heavy. It usually takes a backpack and a plastic bag or two.

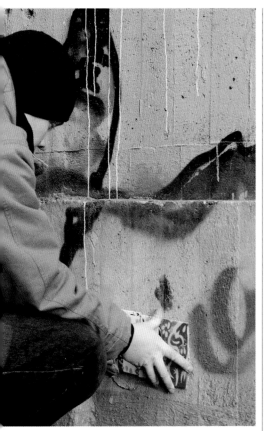

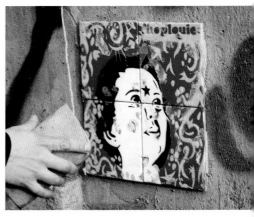

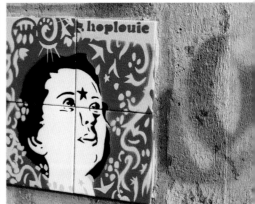

LOCATION

Tile suits surfaces that are smooth but with little structure. Then they adhere best.

I like to work both in places where many people go by and in more hidden spots. The pieces don't last long where cleaners look for unauthorised artistic expression. Where nobody knows whose job it is to remove the artwork, it stays longer.

PUTTING IT UP

When I've found the right location, I pick up the tiles and put them in the right order. Then I remove tape and paper, apply an even layer of cement on the back of the tiles, and press them up where they should be. But first I make a few scores in the cement, separated by a few centimetres. It holds better that way. I bring a sponge and a bottle of water so I can wash off excess cement from the tiles afterwards.

Tile takes some time to put up, so people sometimes come along and wonder what I'm doing with a spackle, cement and a stack of tiles. No-one has been angry so far, but we usually end up discussing anything from types of cement to who public space belongs to.

MARK JENKINS:

Cultivator of the absurd

Mark Jenkins is active in Washington and has worked with street installations since 2003, primarily to affect the public as greatly as possible. He's mainly known for his tape baby sculptures, but also works with many other forms of expression. One of them is placing life-size human sculptures in unexpected spots. Works that break the daily slog and confuse or surprise the viewer with their absurdity.

How did your tape sculpturing start?

When I was a kid I borrowed the tape from the teacher's desk and was messing around with it. I figured out that if it was wrapped in reverse, it copied the surface without sticking to it. I think the strength of the medium is that it's a dry process. With tape I can make a cast of a parking meter on site, crush it down, stick it in my backpack and then get home and stuff it with newspaper and bring it back to life. I can't think of another medium that would have that sort of ability.

What's the difference between doing street art in three dimensions and working on walls?

With 3D, you create an object with physical presence, so you shift from the city as a canvas to the city as a stage. And when you get into hyperrealism, the boundary between the stage and reality gets blurred to the point where it becomes indistinguishable.

What should I think about before getting out there?

Working at night, especially carrying around bodies, looks a little suspicious. In most bigger cities, people aren't paying attention to what's happening around them during rush hour. Use the first ideas you have as a stepping stone to tangent out somewhere new. It takes times.

Tape casting tutorial

This is a DIY for making cast-based tape sculptures.

YOU'LL NEED THE FOLLOWING:
- packing tape
- plastic wrap
- scissors or a razor knife
- an object you'd like to cast

Use cling wrap to wrap the object.

Tape over the wrapped object with two or three layers of tape.

To release the object, take a razor knife or a pair of scissors and make an incision into the cast layer and cut a seam.

Match up the seams and tape together.

Mango's perler bead boards

One day, Mango from Stockholm borrowed his younger siblings' perler bead boards and started creating own motifs. He hopes that his little comments make people's everyday life happier, and dreams of making a life-size Gordon Freeman picture.

HOW DO YOU MAKE A PERLER BEAD BOARD?

There are computer programmes that convert pictures to perler bead format, but it's more fun to make them yourself. When I get an idea, I put it directly onto the board. For larger boards, I start with the contours of the image. Then I add the fill-in. The image appears at once and I can fine-tune it without having to move so many beads.

When I'm ready, I tape the whole board with masking tape. Then I turn it round and iron the back so the beads melt together. The heat makes the board bend a little. Finally I lay a weight on the board to make it even.

A board takes anything from five minutes to five evenings. It depends on how large the image is and how many adjustments I can do. Unfortunately, there are certain limitations to working with pixels. It's hard to make nice curves, for instance.

On the street, I look for surfaces that many people see, for instance above digital bus stop displays. I paste the boards up with PL400 glue. It works on any smooth surface. The edges have to be glued well.

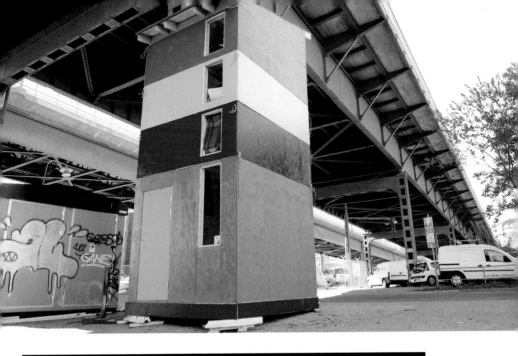

VICTOR MARX:

We have to challenge authority

Victor Marx is an architecture student from Stockholm. He is interested in forgotten urban spots, which can gain appreciation with a few changes, something architects refer to as surgical efforts.

Marx drew much attention in 2009 when he without authorisation built a gallery and a house for the homeless.

How do you choose locations?

I had documented ten or so abandoned places with photos and blueprints. I created a house for the homeless by the Liljeholmen bridge in Stockholm. Homelessness is one of the most unacceptable things in society, a great shame.

I looked for reference material and inspiration from different compact living projects, like Japanese capsule hotels and slee-

per compartments in trains. I also contacted the association of the homeless. The result was a two-floor 7.5 metre tower. Above the entrance is a room with a three-berth bunk bed. Each berth is high enough to sit in and has a little window. A ladder runs right through the house. A ceiling window lets light into the room and can be used as an emergency exit.

The house was built in six parts: a floor block, an entrance module, three bed blocks and a roof module. The blocks have eyelets in each corner and can be lifted with a crane. The structure is reminiscent of Lego, so each bit got its own colour.

Is it important to know a lot about architecture and building work to create this type of work?

You can learn to build during a project if you have someone to guide you. But when you work with buildings this tall, you should

probably be quite used to working with projects. The process is divided into analysis, sketch and execution.

How did you find materials?

I bought them at a building supply store. They can be found for free, but that's very time-consuming. It also leads to a great many special solutions since what you find is often of different dimensions. A good thing about building stores is that they often offer cheap transportation.

The tower is made of wood. I used wooden joists for the bearing structure. The walls were standard, with twice as much insulation as for a summer house.

The floor and roof were built traditionally too. The roof was covered with tarred roofing board.

How did you erect the house?

The house was built in the workshop at the Royal College of Art and freighted with a lorry-mounted crane. We ordered the transportation early since we wanted to start at the same time as ordinary building sites

When the parts arrived, I and about ten associates were on location dressed in overalls. When you work with a crane lorry and large constructions, it doesn't occur to people that you might be doing something illegal.

The previous day, we had attached brackets to one of the bridge's pillars. The ground wasn't quite flat, but we got the bottom module horizontal with bricks and a spirit-level. We stacked the wall modules with the crane and fastened them one by one to the pillar. Then we fastened the modules to each other with nail plate joints.

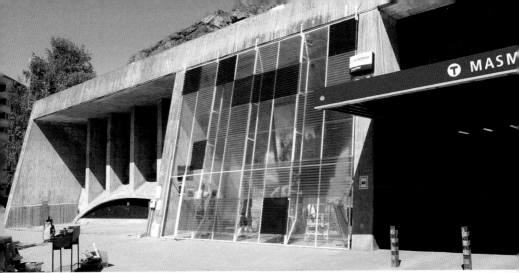

Vitrin Gallery – open to all

Outside the Masmo subway station is a concrete niche that was used as a bicycle stand, but was otherwise abandoned. Without permission, Victor Marx built a gallery that was to function both as a meeting-place and a makeover for the location.

The niche was dressed with corrugated transparent plastic boards on a square tube structure fastened with bolts. The whole structure was fastened with expanding bolts on the upper edge of the niche. The concrete niche was given a transparent and partly coloured plastic wall that fills the opening of the niche and creates a room within. At night, timed lights are turned on and shine through the wall.

The gallery is open 24 hours and is used as a party venue and hangout for youths in addition to exhibitions. A few artworks have vanished, but nothing has been damaged.

MAGDA SAYEG, KNITTA PLEASE:

Be passionate about it!

Magda Sayeg is the pioneer of street knitting. She started knitting at high school in Houston, and when she started Knitta Please in 2005, it was to organise her own, often unfinished, knitting projects. The result was a crew with participants and followers worldwide. Today she lives for and off her art. Shortly before the interview, she knitted a cover for a bus in Mexico City.

How did your interest in street art start?

One day I was particularly bored by the storefront of my local shop. I wanted to make it more homey and more alive so I knitted a little door handle in about five minutes. After that I got some friends together to tag a stop sign pole on my street. The public reaction was astounding. People stopped to look, and there was an article in the local paper. I realized that I had hit on something.

How do you work?

As soon as the details are nailed down and I know the dimensions of the installation, I knit, knit, knit. One small piece is ready in the length of a movie. I have a knitting machine that I use for the major projects. The knitting is attached to the objects

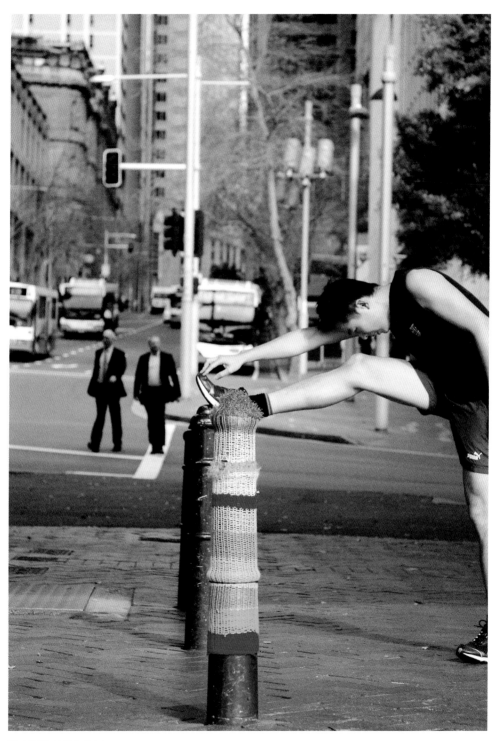

Magda Sayeg in Sydney.

with either plastic zip ties or yarn, or both. A parking meter takes about 10-15 minutes to get all wrapped up. The bus took a week with a knitting machine.

Is the illegal part, in itself, important?

That's been an interesting part of my art. One time a cop stopped me, but when he saw I wasn't using paint he laughed and let me continue. Originally, the unsanctioned part was definitely important. I felt like I was operating outside of traditional channels, challenging expectations and expanding the definition of art, street art, textile craft and so on. Many of my installations today are actually sanctioned.

What are the challenges of knitting in the streets?

Dogs pee on installations. Weather erodes them. There's one still up on a sign in Manhattan, but the pollution and weather have turned its bright yarn just as gray as the city surrounding it. It becomes part of the landscape, merging into it over time.

What are your favourite areas?

I like working in areas that will provoke interaction. When I was in Sydney this summer, I found a huge chess set in a park, where the pawns were the size of large house plants. I knitted hats for them, then watched as old men played chess and moved my knitted pieces around.

What advice would you give a beginner?

Be passionate about it! It has to be something that erupts from inside you. Finding a community is important for inspiration and support.

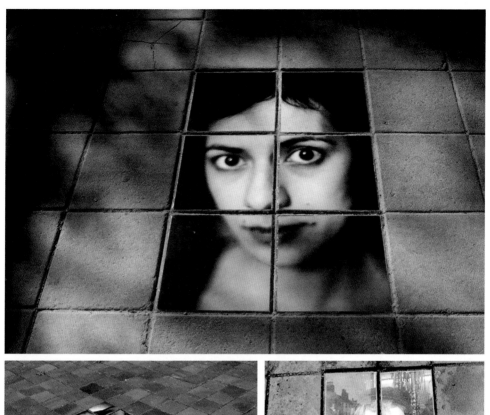

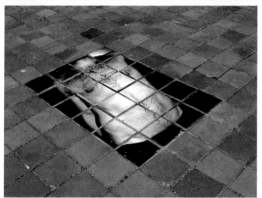 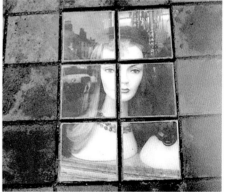

MALMÖ STREETS PROJECT:

Paving stone art

The Malmö Streets Project consists of two Malmö street artists who have been working with installations and adbusting amongst other things for five years. Their paving stones have drawn the most attention.

For your own paving stone: measure the stone, print out a picture and cut it 7 to 8 millimeter smaller than the stone. Laminate the picture and fasten with epoxy glue. Allow to dry. Add five layers of transparent floor varnish.

SLINKACHU:
The city is my playground

The name Slinkachu hides a 30-year-old designer from London, whose hobby is to place small model train set plastic figures on the street. The observant ambler may find miniature brothels, skateboarders in orange peels and burnt-out car wrecks at his feet. Slinkachu runs the blog Little People - a Tiny Street Art Project, and in 2008 published the book "Little People in the City: The Street Art of Slinkachu".

What's your idea?

I use miniature model train set people which I modify, for instance reposing them, removing details of their clothing, or adding contemporary details such as hoods or baggy tracksuit pants. I often use props in my installations too like dead spiders and bees. For this I have a box full of rubbish that might one day come in useful.

Often I have a location where I want the scenes to go. The figures get super-glued down and then I photograph them from different angles until I have captured the story of the installation in one shot.

I then leave the figures to their fate on the street.

Usually an installation will take a couple of hours to make and a couple of hours to place, including travelling. The ideas for the installations can take a while to work out.

Why little people?

I started making art for the street in the summer of 2006. I was working as an art director and really wanted to produce something creative that I could call my own. Little people were just one of those lucky ideas that came to me one day.

I like to explore the loneliness and melancholy of city life and sometimes the danger of it. I try to make work that can seem silly or humorous, but also has depth.

What attracts you to work in the streets?

For anyone working in the streets, including myself, the draw is the freedom to do more or less what you want. I do feel like the city is my playground in a way and I love to surprise.

What reactions do you get from the public?

Children love the miniature figures, and I get a lot of kids sending me their own little people work, which is great to see.

As the themes are universal, the work can be understood by people from all over the world.

The internet has been a great place to display my photography in this regard.

What advice can you give a beginner?

Art that feels like it always should have been in that certain part of a city. My favourite kind of work is stuff that surprises and is inventive with the way it works within its environment.

Light graffiti by Armsrock at the Glow-festival in Eindhoven.

ARMSROCK:
Making a catalogue of city people

Armsrock from Copenhagen has been working in Berlin for several years. He wants to work outside the controlled, commercial and institutionalised art world - to make art more than a segregated form of entertainment and transport it to where people are and real life happens. The light graffiti was made for the Eindhoven Glow festival. The result was a development of earlier work, often influenced by classical painting.

Why do you put up art in the streets?

One of the main factors is my need to interact with my environment. A piece of work on the street has the possibility to engage with every surface and angle, every bit of colour, sound, smell, texture and structure. Maybe the actual works takes place in the moment of engagement. The drawing becomes just one part of the process, as much as the action of placing it in the street is. I want

to take something from the city and give something back at the same time.

For how long have you been doing this?

My first attempts to create art in an urban space happened around 2002. Before that I had been involved in an activist structure where it was common to use urban spaces for various purposes. Graffiti was a great influence for me, as was classical art and the history of direct-action. I started drawing portraits of people and integrating these in the urban structure around 2005. Seen in retrospect it seems that I have been making a catalogue or archive of moments, city people and the way they live.

How is it to work with light?

Light's strange non-presence is really interesting. I feel the same way about light as I do about memory. Weightless insistence, city memory. Working with projections creates an activation of space that I haven't seen in my work before, namely the space bet-

ween the projector and the projected image. The activation, and deactivation, happens instantly, by the flip of a switch, and differs from my previous work which was very much about leaving traces.

What's the story behind your light characters?

I went to Eindhoven, walked around, watched the city and made drawings of what I saw. I wanted to let my drawn recollections of moments I experienced during the day come back in the night. The idea of the project was to intervene with the rhythm and structure of urban space, to give new meaning to the lines of architecture and shed new light on old cracks in the sidewalks.

What materials and technique do you use?

I was working with a Pani projector, which is like a giant slide projector. The one I was using ran around 2600 watts, so it was fairly bright. It runs on slides, 18x18 centimetres. I wanted to retain an aspect of analogue craft, so I developed a bunch of slides black and scratched directly into the surface of the them with an etching needle. Several layers of colour appeared in the slides and also in the projection. I tried to utilize this by putting water on some of the slides to make parts of the developed layer dissolve and then scratching at them with a spoon.

We made the mobile projections using a large shopping trolley and a generator, which was a rather noisy but a practical solution. We also had some long extension cords to be able to pull power from plugs around the town.

Some advantages of working with light?

On an overall aspect it's more legal than working with drawings pasted to walls. In Eindhoven we had time at each location to talk with passing people.

The ephemeral aspect of my pieces in urban spaces fascinates me. This aspect was maintained in my work with light, only in a slightly different way. The drawings would be on the wall for as long as the projector was turned on. Even then one could eliminate them by simply covering the lens. The slides are not very heat resistant and become unsharp after only a couple of days. This means that the drawings can only be used for one project.

Mark Jenkins:
xmarkjenkinsx.com
Victor Marx:
marxarkitektur.se
Slinkachu:
slinkachu.com
Amrsrock:
thinkspaceprojects.com/artists/
armsrock/Graffiti
Research Lab:
graffitiresearchlab.com
Knitta Please:
knittaporfavor.wordpress.com

How to make a Led throwie

LED throwies can put a bit of colour to your environment. They consist of batteries, so-called light diodes/LED lights and very strong magnets. You can choose the number of lights and colours yourself. The magnet can attach your work to a street sign, statue or other metal object. And the light will shine for longer than you think. The pioneers in light-graffiti are Graffiti Research Lab.

MAKE YOUR OWN LED THROWIE
You'll need:

- Batteries (lithium batteries used for watches, pocket calculators and the like).
- Small, but very strong rare earth magnets (made of neodymium).
- 10 mm light diodes/LED lights, at least 2.4 watts, preferably stronger. They can be found in different sizes and colours. There are even blinking ones.
- Tape, soldering tin or conductive epoxy to make it all solid.

1. Test the light by putting its plus side to the battery's plus side, the one that has a greater contact surface than the minus side.

2. Solder, tape or glue the light to the battery. If using tape, do two to three turns around it all. Make sure it's secure.

3. Now solder, tape or glue the magnet to the battery's plus side and tape a few extra turns. Don't forget to keep magnets away from hard drives, memory cards and ID cards. If the magnet gets stuck on something, let it slide off instead of tearing it off.

4. Create your piece by putting lights and colours together.

5. Fasten the piece to a metal surface.
There are several ways to attach a light. Some use clay, others use a bolo with a short string attached to the throwie and a weight on the other end.

GUERRILLA GARDENING

A guerrilla gardener changes the urban environment with earth, water and plants. A roundabout is given new bushes, a demolition site becomes a garden. Activists question how the city is planned and planted. Their weapons? Spades, pickaxes and rakes.

Guerrilla gardeners use forgotten or mis-used areas. Their arguments vary from making the town greener and more pleasant, to a question about who owns public space.

Some also ask how fair the production and distribution of our food is. For most guerrilla gardeners, local participation is a condition for success.

Liz Christy is an important precursor. In 1973, the Green Guerrilla Group took over a backyard in New York and turned it into a communal garden. Today, guerrilla gardening is a growing movement, whose activists spread their experiences on blogs and websites.

Entrance to garden at Esso's ground in Brighton.

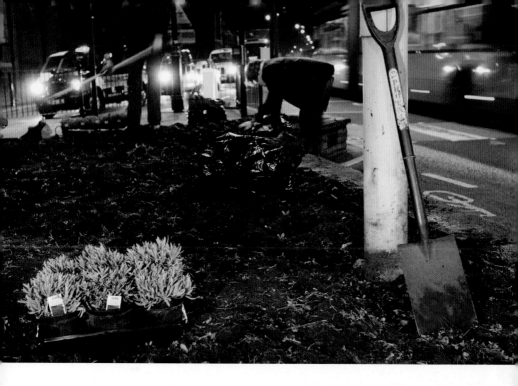

RICHARD REYNOLDS:

Let's fight the filth with forks and flowers

For Richard Reynolds, the mismanagement of his London area became the starting-point for guerrilla gardening. His advice is to do it yourself instead of waiting for institutions and politicians to change the urban environment. Reynolds is the author of the book "On Guerrilla Gardening: A Handbook for Gardening Without Boundaries", and runs a comprehensive network of guerrilla gardeners online.

What's the purpose of gardening in the city?

It's beautification, pride in my local area, a fun activity to participate in, an excuse to talk to local residents, and something of a calling. What we all share is a fearlessness for the barriers that might get in our way, like getting permission from the land owner as well as the possible destruction of our garden. The challenges are about working out how best to share the space, with pedestrians, traffic, dog walkers, contractors and so on.

How did your interest start?

I have always enjoyed gardening, and five years ago I moved to a council managed tower block where the flower beds were in a very poor state. After watching them left neglected for the summer I decided to sort them out myself, and start blogging about it. After a while I discovered others, my website grew in popularity and I got asked to write a book about it.

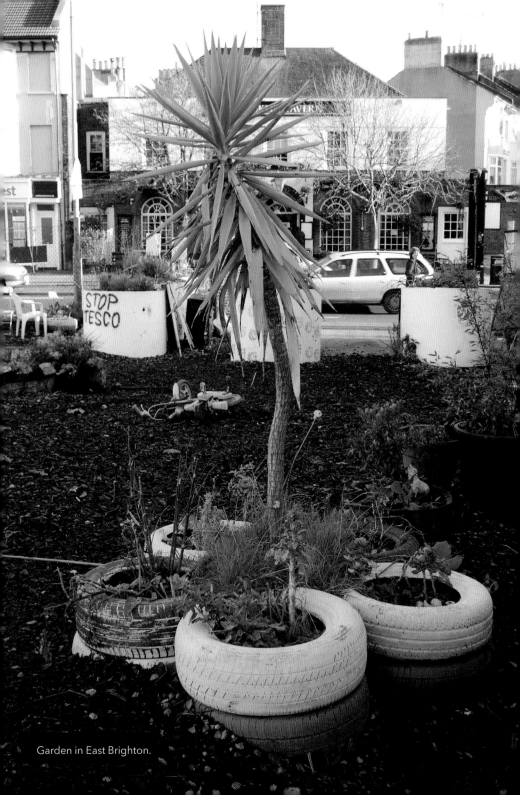

Garden in East Brighton.

RICHARD REYNOLDS:
Guerilla gardening, how to

Here is a basic guide from Richard Reynold's blog. These are not rules, you make them up, you're a guerrilla.

SPOT SOME LOCAL ORPHANED LAND
You will be amazed how many little grubby patches of unloved public space there are. Neglected flower beds, concrete planters sprouting litter and untamed plants, bare plots of mud. Chose one close to home and appoint yourself its parent. This will make it easier to look after.

PLAN A MISSION
Make a date in the diary for an evening attack, when trouble-making busy bodies are out of sight. Invite supportive friends, or perhaps enrol supportive strangers by announcing your attack in the Guer-rilla Gardening Community on the web.

FIND A LOCAL SUPPLY OF PLANTS
The cheaper the better. For city dwellers think local DIY stores, supermarkets and wholesalers. The cheapest plants are the ones that are free. Some-times garden centres will have spare plants to give you for the cause. Or befriend someone with a garden. Think of these private spaces as the training camps for harvesting seeds, cuttings and plants hardened for their big adventure in the wilds of public space. If you have things going spare please leave a message in the Community forum for guerrillas near to where you live.

CHOOSE PLANTS FOR FRONT LINE BATTLE
Think hardy – resistant to water shortages and the cold, and in some locations pedestrian trampling! These plants need to look after themselves a lot of the time. Think impactful – colour, evergreen foliage, scale. These plants need to really make a difference, for as much of the year as possible. Visit the community of gardeners on the web to get advice about specific plants for your part of the world, and to share your horticultural advice. In London I use a lot of herbs like lavender and thyme, tulip bulbs and shrubs.

GET SOME WELLINGTON SHOES
Whilst protecting your feet from mud and providing good purchase on a fork, these rubber shoes also don't look too obviously "agricultural" as the usual boot, and blend in well with the urban environment. I've even worn these clubbing. Wrapping white trainers in carrier bags works effectively, and enables a very convincing clean-footed get-away should you want to whip them off quickly.

BAG SOME BAGS
Plastic bags or bin liners are essential for clearing up the detritus of war. Weeds, litter, flower pots and pebbles need to be carried away. For gentle work reuse wind-blown carrier bags, or for more serious gardening reuse compost bags or giant sacks from builder's merchants. The thick plastic doesn't rip and you can lug a great deal in them to a nearby bin

REGULAR WATERING
One of the responsibilities of a Guerrilla Gardener is ongoing tendering. Water is short in many parts of the world. The Guerrilla Gardener must usually carry water. I have used petrol canisters, they are the perfect water-tight, efficiently-packed portable transportation. But it has caused passers-by to ask if I'm a nocturnal arsonist. One in the web community came up with the genius idea of using old water dispenser bottles. They work extremely well.

SEED BOMBS
For gardening those areas where access is difficult or a long dig is unsuitable, use seed bombs, sometimes called green grenades, which are seeds and soil held in an explosive or degradable capsule. There are many different methods, some you can easily make at home, some require a bit more ingenuity.

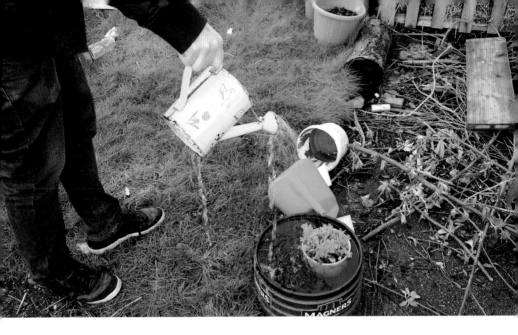

CHEMICAL WARFARE

Boost your plants with natural chemicals. Some guerrillas are lucky to have space for compost heaps. One guerrilla gardener I know lives in a flat with no garden and has employed an efficient army of red worms to help him make his chemical weapons. In a box in the kitchen his "Eisenia fetida" transform food into a rich vermicompost and worm juice fertiliser.

SPREAD THE WORD

Let people know what you have done with a few flyers under doors near the guerrilla gardening war zone, a poster taped to a phone box or bus stop, a marker in the soil. Engage passersby in conversation, perhaps even bring a few spare tools. And welcome local media.

TRANSPORTATION

If you're not guerrilla gardening within walking distance from your home (the ideal) you will need some transportation. My solution has been capacious two-seaters. Convertibles with big wide flat boots enable both trees and large trays of plants to be easily transported.

Guerilla Gardening: A Manualfesto, David Tracey, New Society Publishers
On Guerrilla Gardening: A handbook for gardening without boundaries by Richard Reynolds, Bloomsbury
Richard Reynold's internet community: www.guerrillagardening.org

DAVID TRACEY:

The revolution will be cultivated

David Tracey is a journalist and landscape architect from Vancouver. He runs the company EcoUrbanist and works with Tree City, a group that "helps trees and people to grow together". He exhorts everyone to grow something in their surroundings. Tracey is the author of the book Guerrilla Gardening: A Manualfesto.

How did you get involved with guerrilla gardening?

I got hooked on plants at eight or nine when I tried sowing some carrot seeds and, lo, I grew a carrot. I'm still amazed by the fact that these things actually eat sunshine. Looking into urban ecology convinced me that the future of the planet will be determined by how we create the cities of the future. The "we" here means all of us together, not the financiers, not the developers, not the politicians, not the planners. The key is engaged ecology, a way for citizens to regain their sense of place on the planet, by becoming active creators and caretakers of it. It's also lot of fun – maybe I should have just left it at that.

What does a guerrilla action look like?

A guy living next to some railroad tracks not in use thought it was dumb to leave all that land just for weeds. He started with a single planter box and a few tomatoes. That went well, so he planted a few more boxes the next year. Apart from the food, it was a great way to connect with neighbours and people passing by. The more folks saw him, the more they got inspired, so now there are a number of them with gardens all along the tracks. It looks like an urban farm of the future — the trains may no longer run, but the space is being put to good use.

Is it important to work together?

You should do it as a group, for various reasons: it's more fun, you can share the work, it spreads further that way. But guerrilla gardening is also well-suited to the lone operative type, the kind who works quietly and alone. As for the police, they tend to have more enticing criminals to chase. Even if you're stopped, a simple conversation is probably going to be enough. It's hard to find someone who truly hates plants.

Do you have some useful hints for a beginner?

I could give a longer answer, but really, just plant something. And take care of it. You have to accept the fact that you're taking on a living project.

MOSS GRAFFITI: RECIPE

For those who don't want to use spray paint, moss might be an alternative. Mix your own paste. Apply where suitable. Wait.
This recipe serves to create several small pieces or one large piece of graffiti.

- Several clumps of moss
- 1 pot of natural yoghurt or 12 oz buttermilk
- 1/2 teaspoon of sugar
- Blender
- Plastic pot (with a lid)
- Paint brush
- Spray-mister

Gather several clumps of moss in a bag and take them to a place where you can easily wash them. Carefully clean the moss of as much mud as possible.

Place some of the moss, the buttermilk (or yoghurt) and sugar into a blender and start to mix. This must be done in small phases as the moss can easily get caught in the blades of blender. Keep blending until you have a green milkshake with the texture of a thick smoothie. Pour the mixture into a plastic container. Find a suitable damp and shady wall on to which you can apply your moss milkshake. Paint your chosen design onto the wall. Return to the wall over the following weeks to ensure that the mixture is kept moist. Soon the bits of blended moss should begin to recuperate into a whole rooted plant – maintaining your chosen design before eventually colonising the whole area.

The success of the recipe itself can be very hit and miss and is dependent upon choosing the right location and weather conditions. Moss thrives in the damp and can most often be found growing near to a leaky drainpipe or rain-soaked wall. If you have difficulty finding the right climate in which to grow your moss, grow it indoors (where it can be frequently spray-misted with water) and transplant it outdoors as soon as it has begun to grow. If growing your moss inside you will also need a seed tray containing compost.

10 LINES TO TRY IF YOU GET STOPPED IN THE MIDDLE OF A PLANTING PROJECT

1. Oops.
2. Permission? Did anyone ask the songbirds for permission before we destroyed their habitat?
3. What property line? Oh, that property line.
4. Do you realize that while we've been talking two more species have disappeared from the face of earth?
5. There's no law against beauty, is there?
6. Of course it was all approved.
7. Didn't you get the memo?
8. I'll be glad to rip everything out and restore it back to bare ground… if you're sure that's what the boss would want.
9. Show me the bylaw about reducing the number of flowers we get to see.
10. I'm only doing this because I think our kids deserve to grow up on a planet with clean air and pure water and healthy soil… but what do you think?

Text from David Tracey's book Guerilla Gardening.

How to make a seed bomb

The seed bomb is organic, easy to make and simple to carry on your person. An affordable weapon in the guerrilla gardener's arsenal. Especially when the job needs to be done quickly or an area is hard to reach.

HOW THEY WORK

A seed bomb is a little capsule with everything you need to grow a plant all bundled up

INGREDIENTS:

Powdered clay
Worm castings
Wildflower seeds indigenous to the area
Water
Mixing container
Stick

HOW TO MAKE A SEED BOMB

mix 5 pt powder clay, 5 pt worm castings, 1 pt seeds in a mixing container.

add just enough water to make a nice muddy clay consistency

roll up the mixture into little balls like gum balls

let dry in a cool dry place for like 3 days

throw them in empty fields

The clay has lots of root-encouraging nutrients. The worm castings will give the seeds a nice fertilizer, good for land that hasn't been cultivated or worked on for a while. The indigenous seeds are custom made for your area. They will know how to grow given the conditions.

All they need is a nice rain. The perfect time to throw these is right before a light rainy season. The rain will melt the clay to expose the seeds, and the seed bomb will grow.

Text: Caroline Kim

How to plant trees and bushes

Most trees and bushes need to stand in the sun to give a good crop. Find a place that both the sun and the rain can reach.

YOU'LL NEED:

- A spade
- A skewer (if the ground is hard)
- A watering-can or bucket (10 litres)
- Supporting sticks
- Rope to tie the tree to the stick (bushes don't need support)
- A plastic sack
- (Possibly) a bag of planting soil
- Water

Plant while it's light. Planting in the dark is hard – and why sneak around planting?

PLANTING A TREE

Trees with roots or clumps should be planted in the spring or autumn. Pot-grown trees can be planted at any time, as long as the ground isn't frozen.

Think bed, not hole, when you plant the tree. If you dig a deep hole, as many people recommend, you run the risk of it gathering water. This is not good for the tree, especially in the winter. You also run the risk of the tree sinking into the hole after a while. Dig shallow. The end result should be an elevated bed about 20 cm high and 100-150 cm wide. The bed makes it warmer, provides better oxygen and draining, and increases depth.

Place the soil on a bit of plastic from a plastic sack or similar. This makes it easier to tidy afterwards. If you dig in a lawn, it's important to keep it tidy.

Another common bit of advice is to mix the existing soil with planting soil. But it's often better to put the new soil on top of the old soil, as peat and other organic material biodegrade best on the surface. If you bury organic material, it might result in a lack of oxygen and nitrogen.

In clay, you should loosen the earth at the bottom and on the sides of the hole. This makes it easier for the roots to penetrate the hard earth outside the hole. Now it's a good idea to drive one or more sturdy poles that you will later tie the tree to into the hole.

Water the hole before putting the tree into it. Pull the roots apart in the lower section of the clump when you take it out of the pot. Put the tree down and fill in around the clump. Pack it so it's steady. Tie the tree to the supporting sticks/poles. Water.

Cover the ground with organic material like grass or leaves, and place wood chips or other coarser material on top. Covering it makes it hard for weeds to grow, retains humidity, provides a blanket for useful animals like worms, and breaks down the material to nourishment for the tree, as well as loosening and draining.

It's best to water a lot and not too often. A ten-litre canister once a week for the first summer. If you water little and often, the water doesn't reach far enough and the roots seek their way upwards, making the tree sensitive to drought.

Many buildings have water taps on the outside. To open them, you need a square water key. That's a good investment. You can hide old olive oil canisters in bushes close to the plantation to make watering easier. Ask in restaurants, they often have spare canisters.

CREDITS:

Portrait Benke Carlsson: Jose Figueroa

Portrait Hop Louie: Ivar Andersen

Recipe moss graffiti, text Helen Nodding